IMAGES
of Modern America

LOWELL

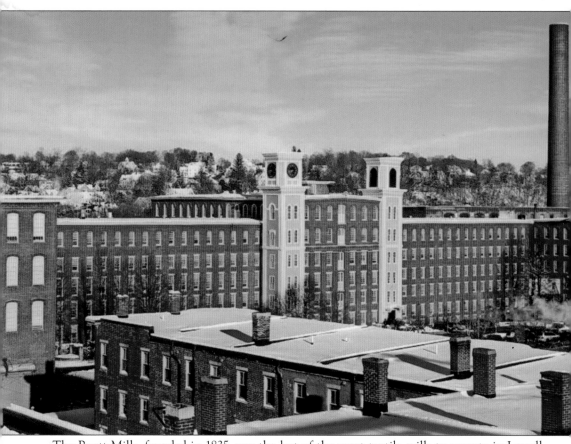

The Boott Mills, founded in 1835, was the last of the great textile mills to operate in Lowell, closing for good in 1956. Two decades later, the National Park Service chose the Boott as the site for a museum about the Industrial Revolution; labor; and the rise, fall, and rebirth of Lowell. (Courtesy of Katie Nguyen.)

On the Front Cover: Clockwise from top left:
Pawtucket Canal at Lower Locks (Courtesy of Ariana Ly; see page 80), African festival dancers (Author's collection; see page 39), Arthur's Paradise Diner (Author's collection; see page 73), Lowell National Historical Park trolley (Courtesy of Katie Nguyen; see page 12), Cote's Market (Courtesy of Mehmed Ali; see page 71)

On the Back Cover: From left to right:
Record Lane (Courtesy of Mehmed Ali; see page 65), Lowell City Hall (Author's collection; see page 64), Buddhist monks blessing house (Courtesy of Mehmed Ali; see page 37)

IMAGES
of Modern America

LOWELL

*For Pat
This was the best of times
Richard P. Howe Jr.
Nov 21, 2015*

Richard P. Howe Jr.

ARCADIA
PUBLISHING

Published by Arcadia Publishing
Charleston, South Carolina

Printed in the United States of America

Library of Congress Control Number: 2015934982

For all general information, please contact Arcadia Publishing:
Telephone 843-853-2070
Fax 843-853-0044
E-mail sales@arcadiapublishing.com
For customer service and orders:
Toll-Free 1-888-313-2665

Visit us on the Internet at www.arcadiapublishing.com

To my father, Richard P. Howe Sr., for sharing with me a love of history, and to my mother, Mary E. Howe, for sharing a love of photography

CONTENTS

ACKNOWLEDGMENTS

Of the many persons I have to thank, foremost is my wife, Roxane. Her 30-plus years of love, companionship, and encouragement made this book possible, and her keen eye helped me find the right photograph for every page. I am also enormously grateful to my son Andrew Howe, whose intellectual curiosity inspires me to look at old things in new ways every day. I could not have completed this book without the generosity of those who shared their photographs with me. For that I am grateful to Ray Houde, Mehmed Ali, the Pollard Memorial Library, Vassilios Giavis, Mary Howe, Jennifer Myers, Dean Contover, Joseph Amaral, Lowell National Historical Park, Rosemary Noon, Peg Shanahan, Roxane Howe, Marianne Gries, Katie Nguyen, Paul Richardson, Bill Walsh, Szifra Birke, Jack and Donna Connell, Sevy Doung, Rodney Elliott, Kevin Harkins, International Institute of New England, Ariana Ly, Patricia Nickles, Steve O'Connor, Tony Sampas, Madylin Perry, Marie Sweeney, University of Massachusetts Lowell, and Fahmina Zaman. I am indebted to Paul Marion and Mehmed Ali for their enthusiasm for this project, their review of the manuscript, and especially their own research and writing, which I consulted continuously. Marie Sweeney's insights into Lowell and its history were invaluable, as was the research and writing of UMass Lowell history professors Robert Forrant and Christoph Strobel. Sean Thibodeau at the Pollard Memorial Library was tremendously helpful, as was Derek Mitchell, formerly of the International Institute of New England. Jack Herlihy and Phil Lupsiewicz at the Lowell National Historical Park and Bryce Hoffman and Christina Hartman at University of Massachusetts Lowell also provided assistance. Thanks also to John Boutselis for training a new generation of Lowell photographers and to Caitrin Cunningham for her guidance and encouragement.

Pictures by Ray Houde (RH), Mehmed Ali (MA), and Pollard Memorial Library (PML) are credited by the abbreviations shown in parenthesis.

INTRODUCTION

Lowell, Massachusetts, burst onto the American scene as the center of American textile manufacturing in the 1820s, powered by the Merrimack River, the ingenuity of its founders, and the labor of immigrants from across the globe. Sadly, Lowell's industrial dominance, while critical to America's industrialization, was short-lived. Improvements in the steam engine in the following decades diluted Lowell's hydropower advantage, and the city's mill owners struggled to compete.

It has been said that the Great Depression arrived early in Lowell and stayed late. Certainly the period between World War II and the 1970s was a bleak time for the city, with Lowell's leaders grasping at every opportunity to drag the city out of its economic malaise. In the late 1950s, they brought federal urban renewal programs to Lowell, and certain established neighborhoods were demolished to make way for "new industry."

Although the new industry never really materialized, urban renewal had the unintended consequence of launching a nascent preservation movement in the city. At the same time, a visionary educator named Patrick Mogan began preaching that Lowell's diversity made it a classroom without walls, perfect for learning about the cultures and traditions of people from around the world. Zenny Speronis, whose Speare House Restaurant rose on the north bank of the Merrimack River, recruited volunteers who organized festivals that celebrated the city's waterways and ethnic heritage. The Commonwealth of Massachusetts played a positive role by creating a Heritage State Park in Lowell and by merging Lowell State College and Lowell Technological Institute to create the University of Lowell (which later became the University of Massachusetts Lowell). Through it all, the people of Lowell worked and worshipped, celebrated and relaxed. In short, they just lived their lives. In doing so, they gave credence to Pat Mogan's vision that Lowell could be an urban laboratory for lifelong place-based learning.

Concurrent with these efforts and ideas, the concept of a national park in Lowell had been quietly progressing since the arrival of the federal Model Cities program in 1965. At some point, the various efforts coalesced, and Congressman F. Bradford Morse and his successors, Paul Cronin and Paul Tsongas, aggressively pursued the idea at the federal level. Their efforts ultimately succeeded, and on June 5, 1978, Pres. Jimmy Carter signed the legislation that created Lowell National Historical Park and the Lowell Historic Preservation Commission. History, heritage, and preservation replaced demolition as the future of Lowell.

A national park by itself could not pull Lowell out of decades of economic doldrums, so city leaders continuously sought other economic development opportunities. In the 1980s, computer maker Wang Laboratories built several facilities, including its world headquarters in the city. A Hilton Hotel was constructed in downtown Lowell, and more than a dozen new public schools were built with 90 percent state funding. In the 1990s, the city, with considerable financial assistance from the Commonwealth of Massachusetts, built a civic arena and an outdoor stadium to house professional hockey and baseball teams. As all of this was happening, hundreds of buildings were

renovated with the help of the Historic Preservation Commission, leaving downtown Lowell with the appearance of a period-piece movie set rather than of a fading industrial community.

These initiatives were not universally successful. Wang filed for bankruptcy, and its office towers were auctioned for a fraction of their value. Another Wang facility, the downtown training center, closed its doors and lay vacant. Without the Wang trainees to occupy its rooms, the hotel bounced from owner to owner without much success. The professional hockey team left town after years of poor attendance, and the arena struggled to break even.

All of these were just temporary setbacks. The Wang Towers, renamed Cross Point, quickly filled with high-tech tenants and has thrived ever since. The abandoned Wang Training Center became the hub of Middlesex Community College in Lowell, and the struggling hotel became the UMass Lowell Inn & Conference Center. The arena was also transferred to UMass Lowell and is now packed with crowds for concerts, shows, civic gatherings, and college sporting events.

As the 21st century arrived, the city repurposed vacant downtown office buildings into artist live-work spaces and general loft living. Driven out of Boston by skyrocketing real estate prices, artists of all types flocked to Lowell, and the city embraced the creative economy as a development strategy. As the birthplace of painter James McNeill Whistler and author Jack Kerouac, Lowell has a great artistic heritage. This new direction was also compatible with the national park's mission of celebrating the heritage and culture of the many immigrant groups that had come to Lowell from the start—and keep coming.

One of the magnets that continues to draw people to Lowell from nearby towns and from countries across the world is the higher educational opportunities offered by Middlesex Community College and especially the University of Massachusetts Lowell. With Lowell native and former congressman Marty Meehan as chancellor from 2007 to 2015, UMass Lowell's endowment doubled, its enrollment increased by nearly half, 10 new campus buildings were constructed, and new research funding from public and private sources flowed into the school. Meehan's transformational leadership at UMass Lowell was so widely recognized that he was unanimously selected in May 2015 to be president of the entire University of Massachusetts system.

Lowell city planners have targeted the 17,000 students at UMass Lowell, especially the 82 percent of the freshmen class now living on campus, as prime customers for the city's downtown restaurants and retailers. Add to that the 5,000 students at Middlesex Community College's Lowell campus and the 3,000 at the city's downtown high school, and it becomes clear that young people and those who support and teach them are key to Lowell's future economic success.

Because of its history, Lowell has many of the components necessary for a city to thrive in 21st century America. Innovation brought the city to life and sustains it today through the efforts of UMass Lowell and cutting-edge high-tech companies. The waves of immigrants and now-relocating urban migrants have infused the community with a cultural vibrancy rare in other American places. The city is socially and ethnically diverse, with many compact neighborhoods that were established before the automobile became the dominant consideration in urban planning. Lowell has a great tradition of bottom-up civic activism and is embracing sustainable approaches to daily life. And thanks to more than $1 billion in public and private funds spent since the 1970s, Lowell's downtown is one of the most picturesque in America, singled out by the National Trust for Historic Preservation as a Distinctive Destination in the United States.

One

RENEWAL

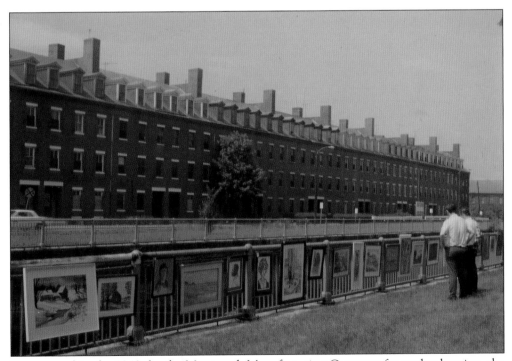

Constructed in the 1840s by the Merrimack Manufacturing Company for worker housing, the Dutton Street row houses were torn down in the 1960s as part of the Northern Canal Urban Renewal project. A small group of Lowell residents vigorously opposed the demolition. Though unsuccessful, many see this struggle as the birth of the preservation movement that transformed Lowell in the following decades. (Courtesy of Joseph Amaral.)

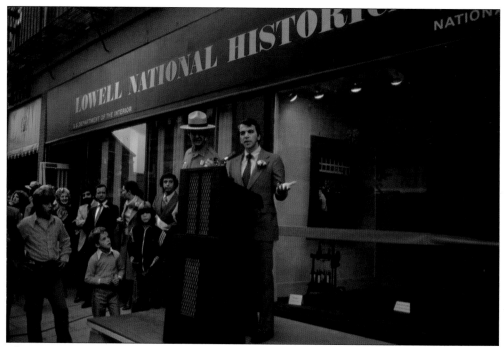

The single-minded determination of Congressman Paul Tsongas (with help from his predecessors F. Bradford Morse and Paul Cronin) brought the bill creating the Lowell National Historical Park to the desk of Pres. Jimmy Carter in 1978. Tsongas is shown here speaking at the first park service office, at 100 Merrimack Street. (Courtesy of Lowell National Historical Park.)

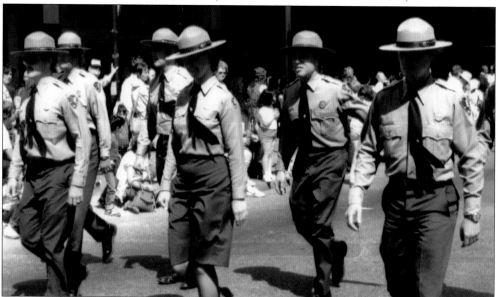

The leadership of the National Park Service initially opposed the creation of a park in Lowell, but a united city provided the political momentum that helped overcome those objections. The people of Lowell celebrated the opening of the park with a grand parade up Merrimack Street featuring the city's initial complement of uniformed park rangers. (Courtesy of Lowell National Historical Park.)

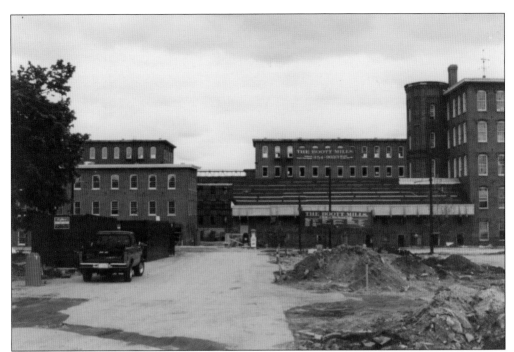

Named for Kirk Boott, one of the founders of Lowell, the Boott Mills opened in 1835 and operated until 1956. Although the Boott had fallen into disrepair, the National Park Service found it to be the most intact of the surviving mill complexes in Lowell and chose it as home for a museum about the Industrial Revolution in America. The *New York Times* wrote of the Boott Cotton Mills Museum soon after its 1992 opening, "The Lowell park and museum realize an imaginative scheme put forward in the 1970's by former Senator Paul Tsongas, a child of Lowell. Restoring the old canals and the long-shuttered mills has given new hope and dignity to a Lowell now entering the post-industrial revolution." (Above, courtesy of Dean Contover; right, author's collection.)

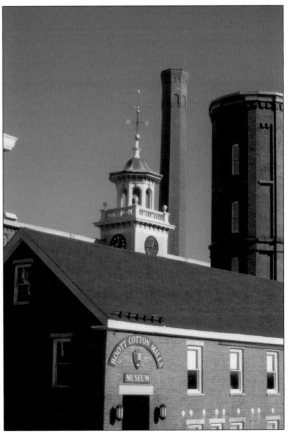

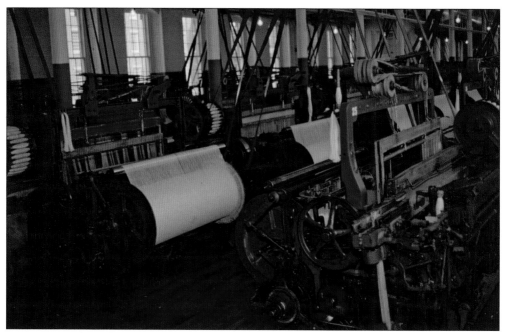

Visitors arriving at the Boott Cotton Mills Museum are issued foam ear plugs to protect against the jarring noise of 80 power looms turning cotton thread into cotton cloth. A single loom would illustrate the technology; 80 of them provide a glimpse of what generations of mill workers experienced each day on the job. (Courtesy of RH.)

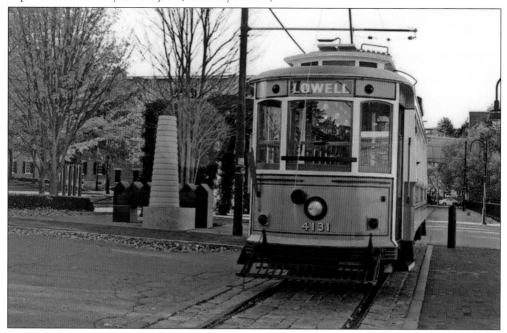

A once-vibrant street railway made its last run in Lowell in 1935, but the arrival of the park began the revival of Lowell's trolleys. Using replicas of classic New England open cars manufactured by the Gomaco Trolley Company of Ida Grove, Iowa, the new Lowell streetcar line opened in 1988 with 1.2 miles of track. (Courtesy of Katie Nguyen.)

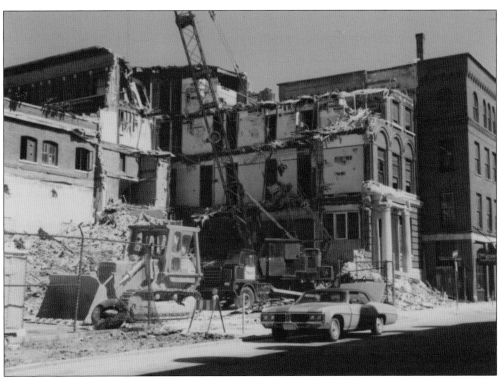

The immense scale of Lowell's mills made the city a leader in the early American railroad industry with the Boston & Lowell Railroad Corporation chartered in 1830. Huntington Hall, at the corner of Merrimack and Dutton Streets, served as the city's main train station until it was destroyed in a 1904 fire. In 1910, the Lowell YMCA was constructed in its place. Moving to other quarters in 1975, the Y sold the parcel to the Commonwealth of Massachusetts, which demolished the building to make way for the Lowell Heritage State Park. To commemorate the city's railroad heritage, the National Park Service and the Boston and Maine Historical Society obtained, refurbished, and emplaced B&M engine No. 410, manufactured in Manchester, New Hampshire, in 1911, on the site of Huntington Hall. (Both, courtesy of Vassilios Giavis.)

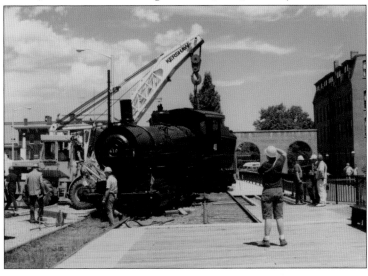

Lowell mill owners constructed and operated worker housing alongside the mill buildings but eventually tore down or sold most of the boardinghouses. In the early 1980s, the US Department of the Interior acquired the surviving Boott Mills boardinghouse, then home to H&H Paper Company, and the adjacent parking lot. Renamed the Patrick J. Mogan Cultural Center after the visionary Lowell superintendent of schools who many consider to be the father of Lowell National Historical Park, that boardinghouse now features the mill girls and immigrants exhibit of Lowell National Historical Park. The parking lot was transformed into Boarding House Park, a lush, grassy performance venue that each year plays host to the Lowell Summer Music Series and the Lowell Folk Festival. (Above, courtesy of RH; below, courtesy of Jennifer Myers.)

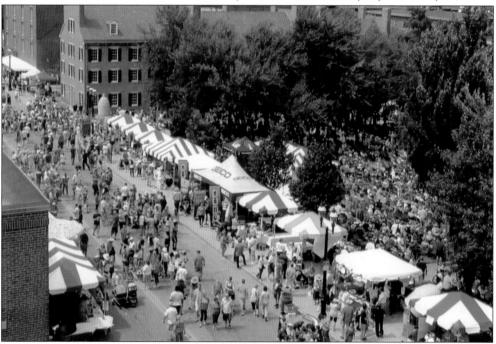

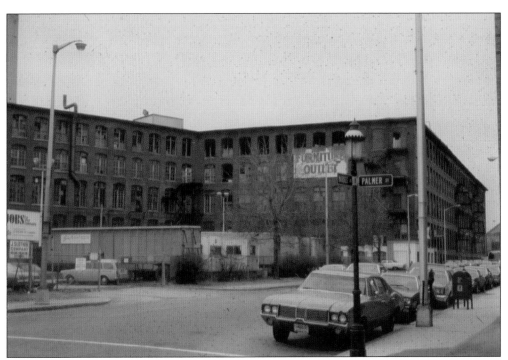

In 1828, the Lowell Manufacturing Company built a large mill complex along Market Street to manufacture cotton cloth and carpeting. After the Civil War, the growing American middle class made the production of carpet more lucrative, so the Lowell firm merged with one founded by Erastus Bigelow to create the Bigelow Carpet Company. Despite extensive renovations in the early 1900s, Bigelow moved to Connecticut in 1914, and the Lowell complex closed. In the 1970s, Paul Tsongas brought together public and private interests to build the Market Mills project, which created hundreds of units of housing, first-floor retail space, the visitor center of Lowell National Historical Park, and a 1984 bronze-and-granite sculpture by Mico Kaufman called *Homage to Women*. (Above, courtesy of PML; right, author's collection.)

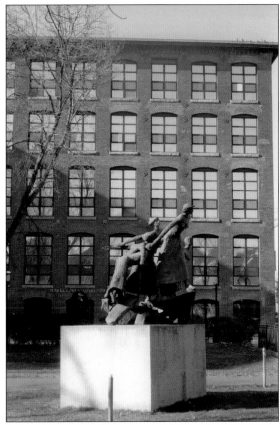

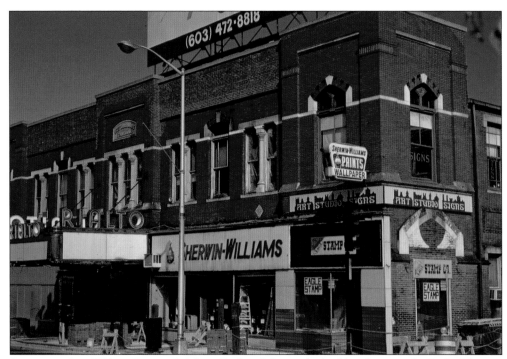

Constructed in 1876 as a Boston & Maine Railroad depot, the building became the Rialto Theatre in 1900 when the city's train stations were consolidated on Middlesex Street. The Rialto survived a series of ownership changes, including a foreclosure during the Great Depression, and in the 1960s became a bowling alley that retained the Rialto name. In 1984, local developer James L. Cooney Jr. purchased the property, but he eventually donated it to the National Park Service, which over the next two decades restored the exterior to its original appearance. In 2008, the federal government transferred the building to Middlesex Community College, which will use it for its theater and performing arts programs. (Above, courtesy of RH; below, author's collection.)

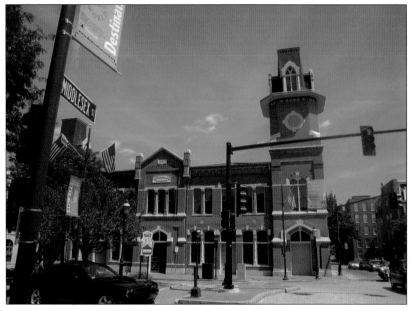

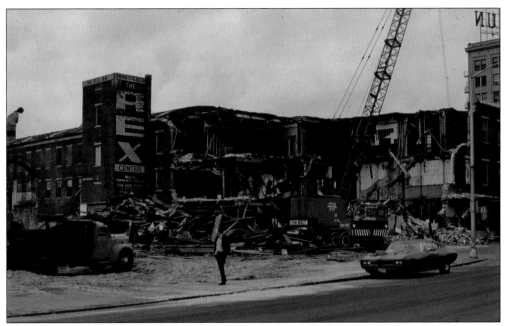

The Rex Center on East Merrimack Street was home to a bowling alley, Turkish bath, and radio station WLLH, where Tom Clayton, Ed McMahon, and others kept the residents of Lowell informed and entertained. After its demolition in the 1960s, the Rex property was a parking lot until the construction of the Wang Training Center in the 1980s. (Courtesy of RH.)

To better complement the preservation work that was restoring many downtown buildings to their 19th-century appearance, in the 1980s the city began replacing modern paving materials in many downtown intersections with cobblestones, which along with benches and vintage lampposts enhanced the overall appearance of downtown. (Courtesy of RH.)

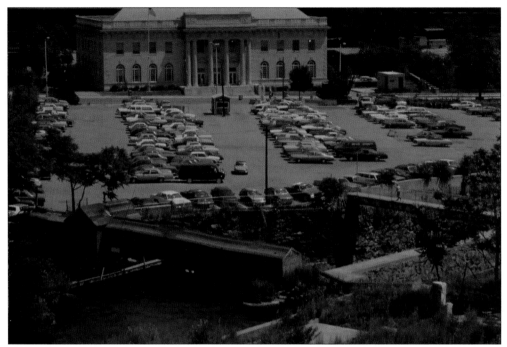

During the 19th century, two of Lowell's earliest mill complexes, the Middlesex Company and the Massachusetts Cotton Mills, straddled the Pawtucket Canal as it passed through the Lower Locks and into the Concord River. Major portions of both mills were demolished in the mid-1900s, with two parking lots, the Rex and the Smith, taking their place. In the mid-1980s, the 251-room, nine-story Lowell Hilton Hotel was built on the Smith Lot, and the five-story Wang Training Center was constructed across the canal on the Rex Lot. Both were central to Lowell's economic revival. (Above, courtesy of PML; below, courtesy of RH.)

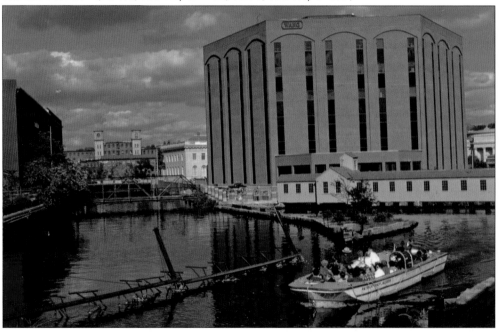

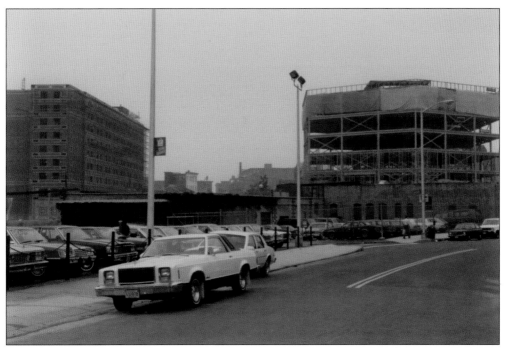

When the developer of the Lowell Hilton Hotel expressed doubt about its viability downtown, the city administration overcame the objections by reconfiguring the street network, constructing a 1,000-car garage, and eliciting a promise from Wang to house its trainees in the hotel. Both the Lowell Hilton and the Wang Training Center opened in 1985 to rave reviews, but the downturn in high tech caused Wang to abandon its building, and the hotel never recovered from the lost occupancy. In 1990, Middlesex Community College moved into the Wang Training Center, and in 2010, the University of Massachusetts Lowell took over the hotel and renamed it the UMass Lowell Inn & Conference Center. (Above, courtesy of Vassilios Giavis; below, author's collection.)

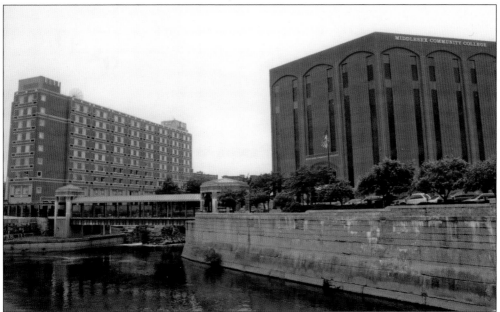

Paul Tsongas's vision for Lowell's revival included minor-league baseball, but for that the city needed a suitable stadium. A long-underutilized parcel on the south bank of the Merrimack River was selected. City leaders, led by Edward A. LeLacheur, a state representative who was nearing the end of a long and distinguished legislative career, convinced the Commonwealth of Massachusetts to pay much of the $11.2 million needed to construct the field. Designed by HOK Sports, the architect of Oriole Park at Camden Yards, the Lowell park opened in 1998 and was named for LeLacheur. Edward A. LeLacheur Park is home to the Lowell Spinners, a Class-A affiliate of the Boston Red Sox, and the UMass Lowell River Hawks baseball team. (Above, courtesy of MA; below, author's collection.)

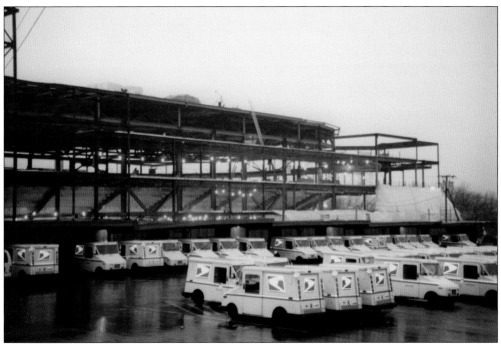

In the face of considerable local opposition, Paul Tsongas led the fight in the mid-1990s to build a multipurpose arena in Lowell. With funding coming from the Commonwealth of Massachusetts, University of Massachusetts Lowell, and the City of Lowell, ground was broken on a large parcel adjacent to the city's post office in 1996. The grand opening of the arena on January 27, 1998, featured a UMass Lowell River Hawks hockey game and an emotional ceremony dedicating the facility to Tsongas, who had died a year earlier at age 55 from complications from cancer. In 2009, the City of Lowell transferred ownership of the arena to UMass Lowell, which renamed it the Paul E. Tsongas Center at UMass Lowell. (Above, courtesy of MA; below, courtesy of Madylin Perry.)

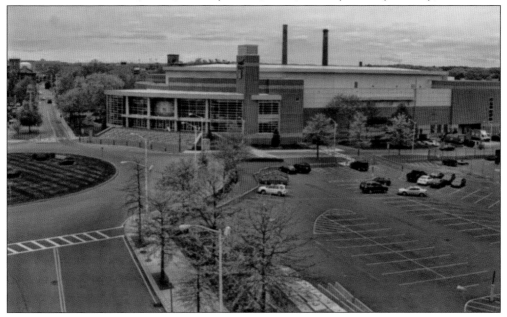

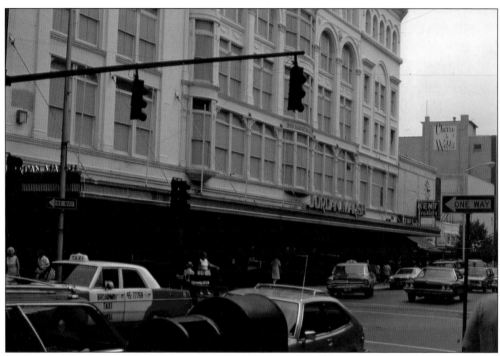

Frederic Mitchell opened his first store in 1878 and was soon calling it the Bon Marché. Advertised as the largest department store in New England, the Bon Marché sold quality consumer goods at prices that its mill-working customers could afford. The persistence of tough economic times in Lowell led the Bon Marché to finally close in 1976, after which the property was occupied by a Jordan Marsh store for another decade. After several years of standing vacant, the 120,000-square-foot building was purchased by the Lowell Development & Financial Corporation, which enlisted two local developers, Nick Sarris and George Behrakis, to renovate the building and fill it with tenants ranging from Wang to the Lowell School Department. (Above, courtesy of PML; below, author's collection.)

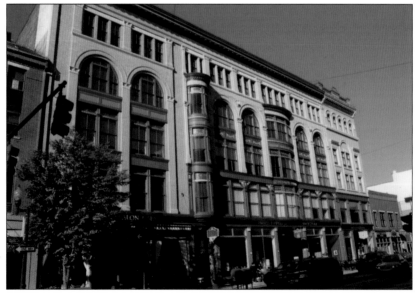

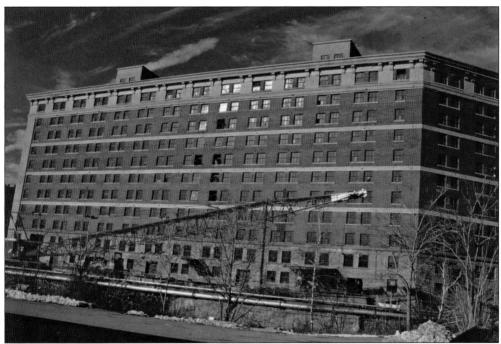

A lack of open space presented an obstacle to the conversion of Lowell's surviving mill buildings to housing, so in 1986, the city took by eminent domain the massive Curran-Morton warehouse on Bridge Street. Built as a cotton bale storehouse for the Massachusetts Mills, the six-foot-high ceilings and thick concrete floors of the warehouse made it an unlikely candidate for reuse. Its subsequent demolition was not only a catalyst for residential developments in the adjacent Massachusetts and Boott Mills, but also cleared the way for Kerouac Park, which honors Lowell's most famous author, Jack Kerouac. (Above, courtesy of RH; below, courtesy of Dean Contover.)

Once home to the massive Lowell Machine Shop complex, the multi-acre site along Dutton Street and the Merrimack Canal became home in the 1960s to the cement block and aluminum buildings of modern textile companies such as Pellon and Freudenberg. When they departed in the 2000s, the City of Lowell acquired the site for the Hamilton Canal District development project. (Courtesy of PML.)

Swamp Locks, one of four lock chambers that drop the Pawtucket Canal 32 feet over its 1.5-mile length, is the launching point of national park boat tours and is also at the center of the Hamilton Canal District, a city redevelopment project that will reinvent 15 acres of vacant and underutilized land as a vibrant mixed-use neighborhood. (Author's collection.)

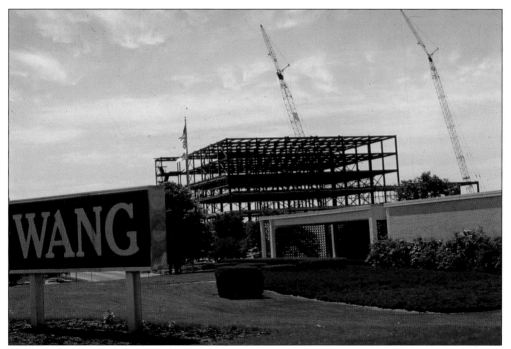

Wang Laboratories began construction of its new world headquarters on Chelmsford Street in 1980. Soon, three interconnected 12-story towers totaling 1.2 million square feet of space and costing $60 million made Wang the largest employer in Lowell. After Wang's 1992 bankruptcy, the towers sold at auction for $525,000. Renamed Cross Point, the buildings were soon fully occupied and sold again in 2014 for $100 million. (Courtesy of RH.)

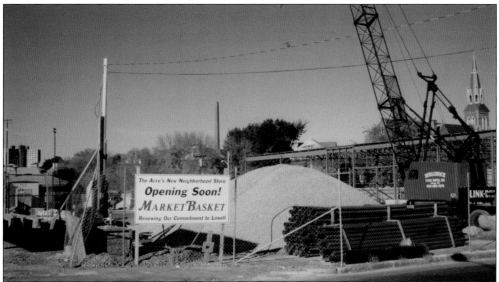

DeMoulas Super Markets grew from a single store into the massive Market Basket chain of 75 stores and 25,000 employees. The DeMoulas family retained its roots in the Acre, building a brand new store in the neighborhood that served as a catalyst for the area's revitalization. The company survived an ownership dispute in the summer of 2014 and remains as strong as ever. (Courtesy of MA.)

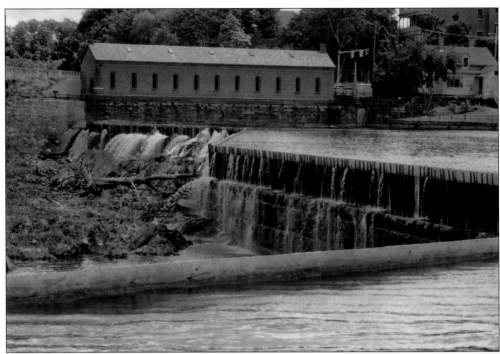

The founders of Lowell constructed a wood and masonry dam across the Merrimack River at Pawtucket Falls in 1826 to raise the level of water flowing into the nearby Pawtucket Canal. A reconstruction in 1875 placed granite blocks along its 1,000-foot length. Set into the top of the granite were iron pins and wooden flashboards designed to accommodate the flow of the water by bending and breaking. In the first decade of the 21st century, the international energy company that owns a hydropower plant in the city petitioned the Federal Energy Regulatory Commission (FERC) for permission to replace the historic dam with a motorized system of air-filled rubber bladders. Despite the opposition of the national park and neighbors, the petition was allowed. (Both, author's collection.)

Two

WELCOME

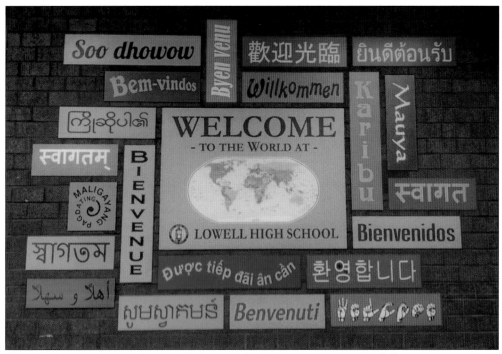

A sign at the entrance to Lowell High School welcomes visitors in 21 different languages and symbolizes the diversity of the school and the city it serves. It is also a reminder that the mission of Lowell National Historical Park is twofold: to tell the story of the Industrial Revolution but to also tell the story of the immigrants whose labor made it all possible. (Author's collection.)

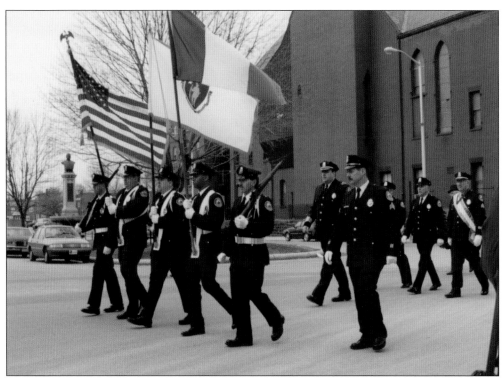

In Lowell's 1822 infancy, Hugh Cummiskey, an immigrant from Northern Ireland, led the first group of Irish laborers to Lowell to help dig the canals and build the mills. Many followed. The 1855 state census identified 10,369 native-born Irish out of a total population of 37,553. Another major migration in the 1890s further increased the number of Irish in Lowell. While St. Patrick's Day has always been celebrated, the Irish community has for more than three decades observed Irish Cultural Week, which begins with a procession from St. Patrick's Church to city hall for the raising of the Irish flag followed by seven days of cultural events. (Above, courtesy of Mary Howe; below, courtesy of MA.)

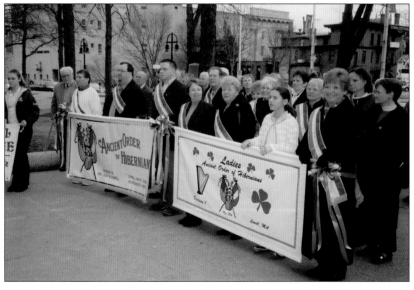

A post–Civil War boom caused Lowell's mills to send agents to Quebec in search of low-cost labor. The industriousness of the thousands of Franco Americans who came contributed to the city's economic expansion, while their commitment to their religion and culture enriched the city's soul. Here, parishioners of St. Jean Baptiste Parish prepare to raise the flag of Quebec. (Courtesy of PML.)

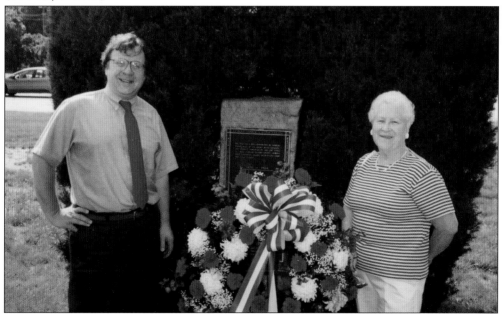

Many of Lowell's French Canadians settled in Little Canada, a neighborhood of densely packed wood-frame tenements near the mills. Many remember Little Canada as a proud, vibrant community and regret its 1960s demolition in the name of urban renewal. Here, Paul Marion and 1996 Franco American of the Year Monique Blanchette lay a wreath at the Little Canada memorial. (Courtesy of MA.)

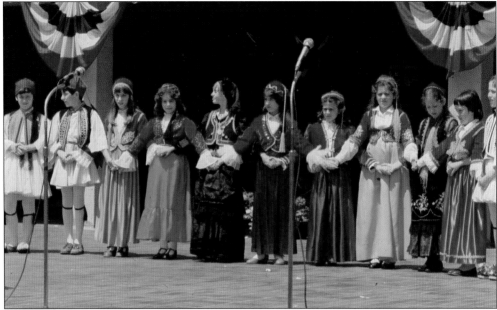

During the last decade of the 19th century, newcomers from Greece joined the stream of people from southern and central Europe flowing into Lowell. The Greeks went to work in the mills and settled in the Acre, where their language, religion, and culture thrived. By 1910, more than 20,000 Greeks lived in Lowell; the Byzantine-style Greek Orthodox Holy Trinity Church was dedicated in 1908. Today, Greek American residents of Lowell annually celebrate Greek Independence Day with a procession from Holy Trinity Church that includes laying wreaths at Greek monuments in the Acre, raising the Greek flag at city hall, and cultural performances by students from the Hellenic-American Academy. (Above, courtesy of RH; below, courtesy of Rosemary Noon.)

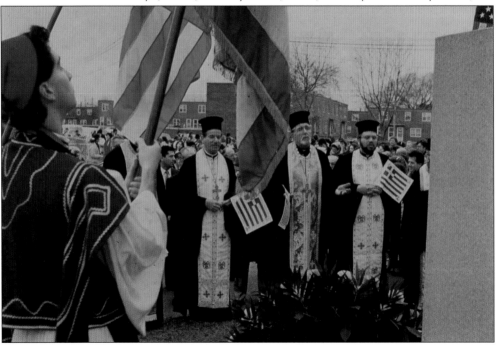

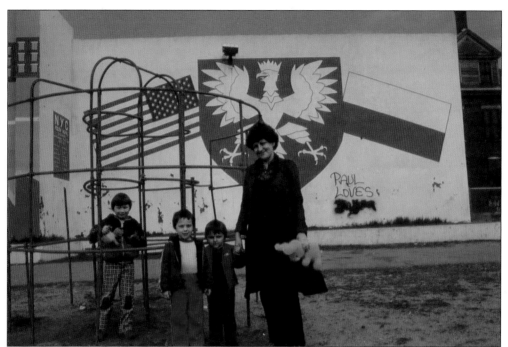

By 1918, more than 5,000 Polish immigrants had come to Lowell, where they settled in Polish-speaking clusters in neighborhoods such as Centralville from which they could walk across the Merrimack River bridges to work in the mills. Catholic churches with liturgies in Polish and social clubs such as Dom Polski have kept Polish culture alive in Lowell. Above, a family stands before the Polish White Eagle mural painted on the side of the city pumping station off West Sixth Street. At right, the color guard of the Polish American Veterans organization participates in a Memorial Day program. (Above, courtesy of PML; right, courtesy of RH.)

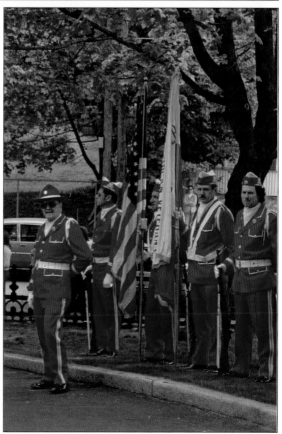

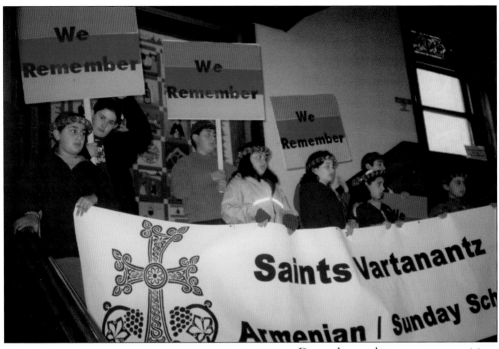

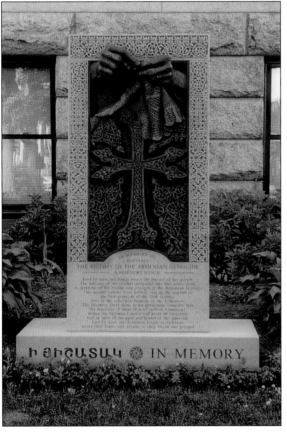

Drawn by employment opportunities after having been driven from their homeland by political persecution and massacres, many Armenians came to Lowell during the early decades of the 20th century, with most settling in the Chapel Hill neighborhood. Saints Vartanantz Armenian Apostolic Church opened on Lawrence Street in 1916 and played an important role for the Armenian community of Massachusetts by providing religious, social, and cultural services. With funds raised by the Merrimack Valley Armenian Monument Committee, a bronze-and-granite Armenian Genocide Monument was unveiled on the grounds of Lowell City Hall in May 2014. (Above, courtesy of MA; left, author's collection.)

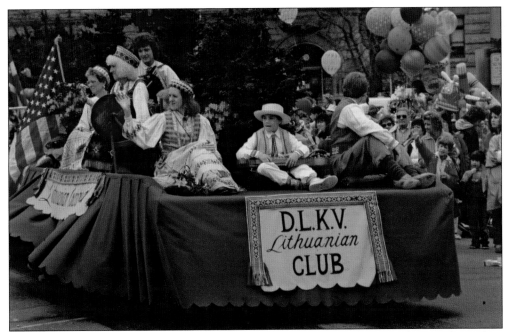

Hundreds of Lithuanians arrived in Lowell in the years before World War I. They sought work in the mills and established a Lithuanian church, St. Joseph's, on Rogers Street. They also established a Grand Duke of Lithuania Vytautas (DLKV) Club to help perpetuate Lithuanian culture at civic celebrations, festivals, and parades. (Courtesy of RH.)

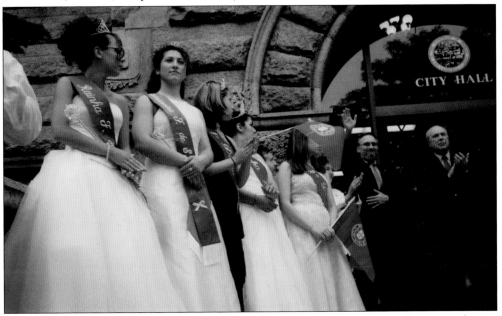

Portuguese immigrants first came to Lowell in the 1890s and early 1900s, with most settling in the Back Central neighborhood, where they established St. Anthony's, a Catholic parish that continues to hold liturgies in Portuguese, along with social clubs and small businesses. Enhanced by more recent arrivals from the Azores, the Portuguese community of Lowell actively celebrates its language and culture throughout the year. (Courtesy of MA.).

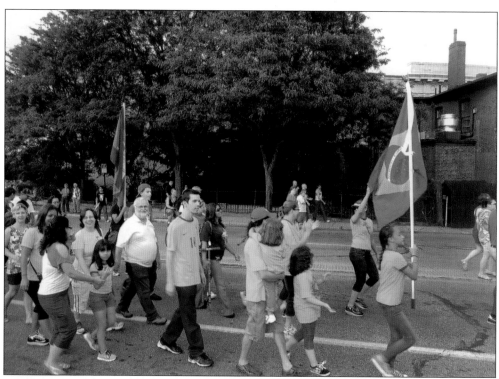

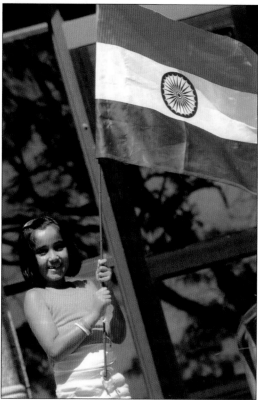

Lowell's population of Portuguese speakers increased significantly with the arrival of immigrants from Brazil, who came to Lowell in the 1960s for greater economic opportunity. While many took construction jobs, others worked at textile firms such as Joan Fabrics and Freudenberg Nonwovens. Many became entrepreneurs, establishing Brazilian restaurants, insurance agencies, convenience stores, and other small businesses. (Author's collection.)

By 2010, between 3,000 and 4,000 Indians lived in Lowell, mostly in the Middlesex Village neighborhood, which is home to several Indian stores and restaurants and two Swaminarayan temples. Language and cultural preservation are very important in Lowell's Indian community, which consists of many in professional or technical occupations, but also an increasing number in blue-collar jobs. (Courtesy of Jennifer Myers.)

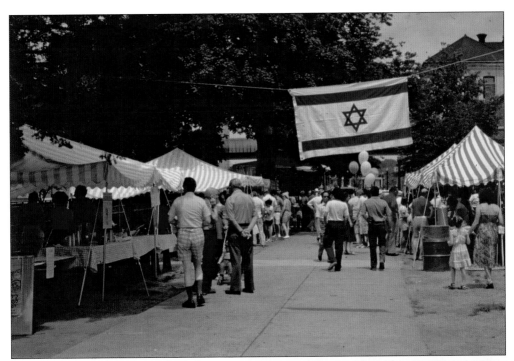

After 1890, many Russian and Polish Jews passing through Ellis Island and New York City eventually came to Lowell, with most settling in the Highlands neighborhood around the intersection of Hale and Howard Streets. By the 1970s, many in the Jewish community had moved to the upper Highlands, but by 2000, most had moved out of Lowell to neighboring suburbs. (Courtesy of RH.)

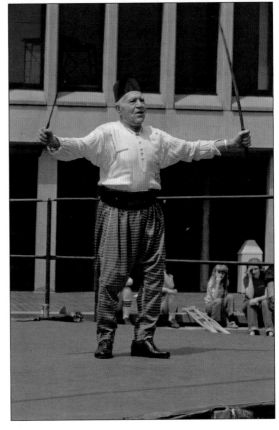

The first Syrian-Lebanese families came to Lowell in the mid-1880s. Lewis Zaher, who owned a popular neighborhood variety store on Pine Street in the Highlands into the 1970s, helped preserve the culture of his native Syria by performing the traditional sword dance at civic events such as the Regatta Festival. (Courtesy of RH.)

Lowell residents watching the fall of South Vietnam and related turmoil in Southeast Asia on network television in 1975 never imagined that those events would transform the city. Many Southeast Asians who had helped the United States and faced death or imprisonment at home made their way to America, with some reaching Lowell in the late 1970s. Some of the early arrivals were Roman Catholic and welcomed at St. Patrick's Church, which continues to hold services in Khmer and Vietnamese. Other newcomers established small businesses such as the Phnom Penh Market and a Buddhist temple that combined to form a Khmer infrastructure that attracted thousands of Southeast Asians who had initially settled in other parts of the United States. (Above, courtesy of PML; below, courtesy of RH.)

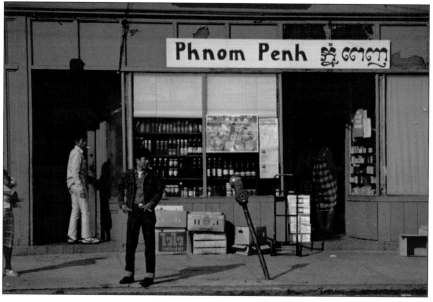

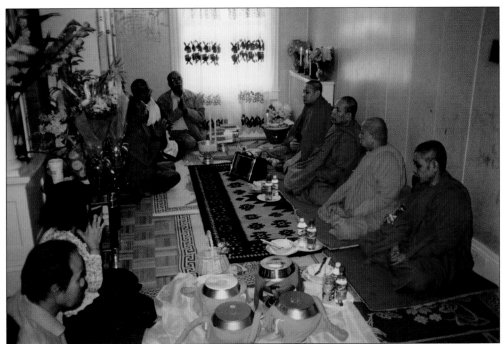

Businesses, temples, and cultural institutions established by early-arriving Cambodians combined with the booming economy of the mid-1980s "Massachusetts Miracle" to draw thousands who had initially been settled by the federal government in other states in a secondary migration that caused Lowell's Cambodian population to quickly swell to nearly 30,000, making Lowell the second-largest Cambodian population center in America after Long Beach, California. Through religious observances and cultural celebrations, the Lowell Cambodian American community has preserved the traditions of Southeast Asia while broadening the cultural horizons of many longtime Lowell residents. (Above, courtesy of MA; right, author's collection.)

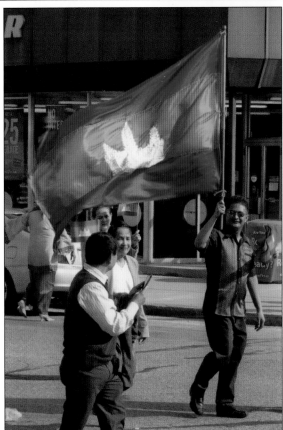

While not nearly as numerous as the city's Cambodian population, many refugees from Vietnam and Laos came to Lowell in the late 1970s as a direct result of the Communist victory in South Vietnam. Their journey here was perilous, often in rickety boats with few resources, but because they had sided with the Americans in the war, they felt little choice but to leave. Those who came later were motivated by a desire to reunify families and a quest for greater economic and educational opportunities. The continued impact of the Vietnam War is evident in the South Vietnamese flag being carried by the men marching above and the Lao American Heritage and Freedom Anniversary celebration below. (Above, author's collection; below, courtesy of Jennifer Myers.)

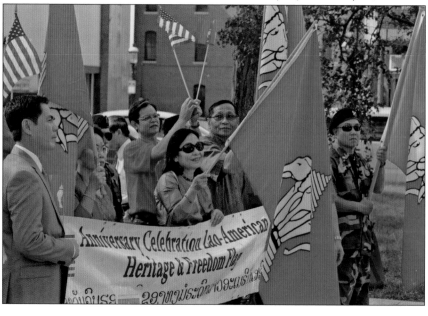

Residents of Puerto Rico began moving to Lowell in the early 1960s, with the city's Puerto Rican community growing to nearly 8,000 by 2008. Each year since 1980, the city's Puerto Rican Festival celebrates music, dance, food, poetry, and other cultural activities while serving as a gathering of the city's Latino community. (Courtesy of RH.)

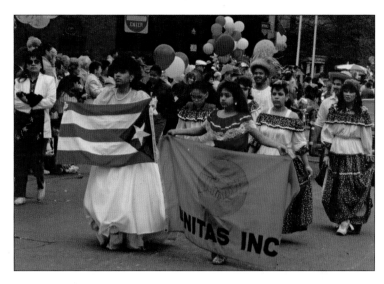

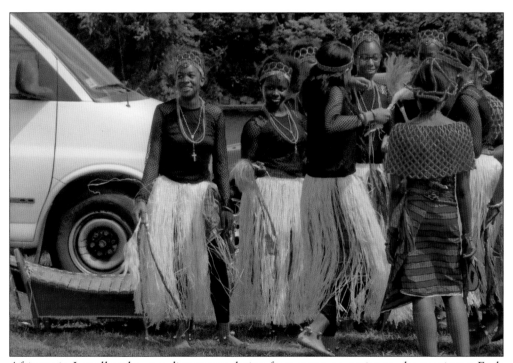

Africans in Lowell make up a diverse population from many countries on the continent. Each year, the Lowell African Festival attracts thousands of Africans and lovers of African culture to the bank north of the Merrimack River to celebrate traditional and modern African food, music, and arts. Here, dancers in traditional dress prepare to take the stage at the 2014 festival. (Author's collection.)

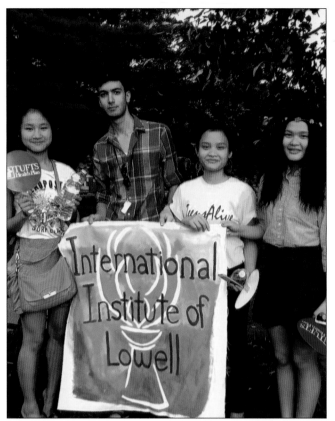

Created in 1918, the International Institute of Lowell (now, of New England) has assisted in the resettlement of immigrants in Lowell for nearly a century. By 2015, most of the institute's clients were refugees from Burma, Republic of Congo, Iraq, Somalia, and Bhutan, directed to Lowell by the State Department's Bureau of Population, Refugees, and Migration. Having fled political or religious persecution or war, these new residents of Lowell face particular challenges in their new home, but with the assistance of organizations like the International Institute, they quickly adapt to the rhythms of the community and remain active by assisting at events organized by the institute. (Left, courtesy of International Institute of New England; below, author's collection.)

Three

CULTURE

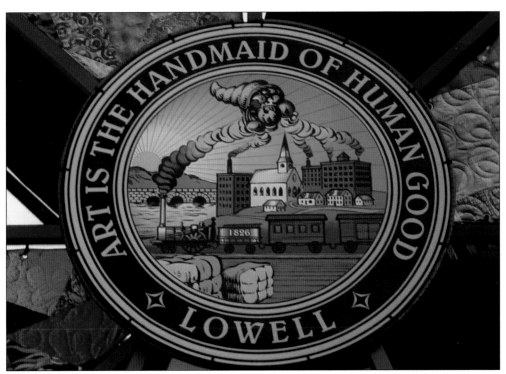

Adopted in 1836, the city seal depicts many of the elements that contributed to Lowell's 19th-century greatness, including mills, canals, railroads, and bales of cotton. Although the city motto, "Art is the Handmaid of Human Good," referred to the mechanical arts, residents have expanded its meaning to encompass all aspects of culture, including the city's recent embrace of the creative economy. (Courtesy of Marianne Gries.)

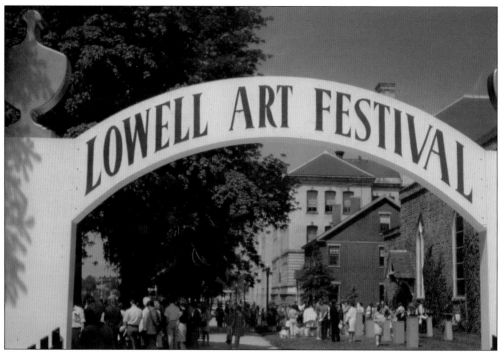

Beginning in 1960, the Lowell Art Association sponsored the annual outdoor art festival at Lucy Larcom Park during the first weekend of June, exhibiting paintings and sculpture interwoven with music and dance performances. Artists exhibiting their works at the 1968 festival included Janet Lambert Moore, Richard Marion, Bernard Petruzziello, Donald Sullivan, Selma Swatz, Ann Kelakos, Albert Laferriere, and others. The Lowell Art Association was founded in 1904 and took advantage of the surge in interest in the work of James McNeill Whistler after the artist's death by purchasing and rehabilitating the home in which he was born on Worthen Street, now called the Whistler House Museum of Art. (Both, courtesy of Joseph Amaral.)

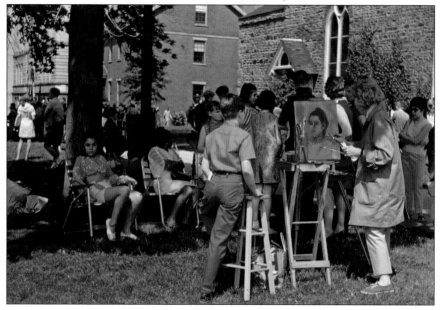

A graduate of the Massachusetts College of Art and Design, Vassilios "Bill" Giavis has specialized in painting Lowell scenes, especially notable residents and historic buildings such as the Eliot Church. He maintains a studio in the Brush Art Gallery at Market Mills and in 2013 was named the first artist-in-residence of Lowell National Historical Park. (Courtesy of Vassilios Giavis.)

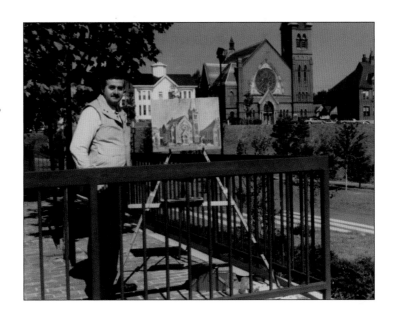

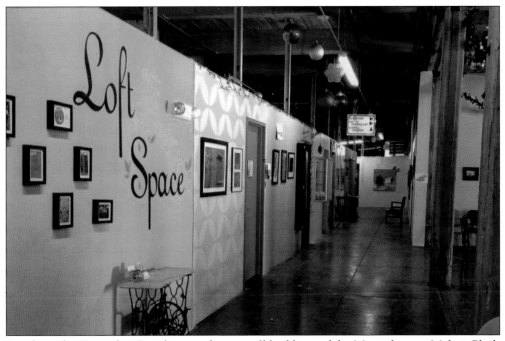

Set along the Pawtucket Canal in two former mill buildings of the Massachusetts Mohair Plush Company, Western Avenue Studios opened with 31 artists in 2005. By 2015, more than 300 artists had studios and some live-work spaces at Western Avenue, which opens its doors to the public on the first Saturday of every month, drawing thousands from around the region to view and purchase original art. (Author's collection.)

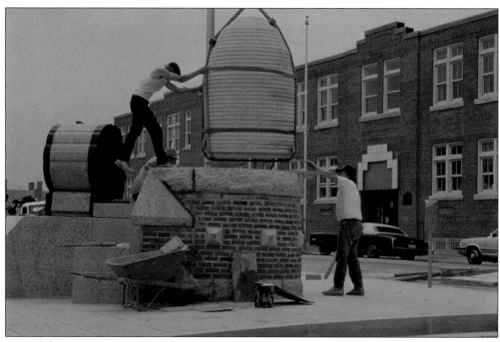

One of three companion pieces by Connecticut artist Robert Cumming installed on corners of Boarding House Park in 1990, *Lowell Sculpture One* is a six-ton silhouette of Francis Cabot Lowell (the man for whom the city is named) backed by a granite thread spool mounted on a brick-and-granite base. (Courtesy of Rosemary Noon.)

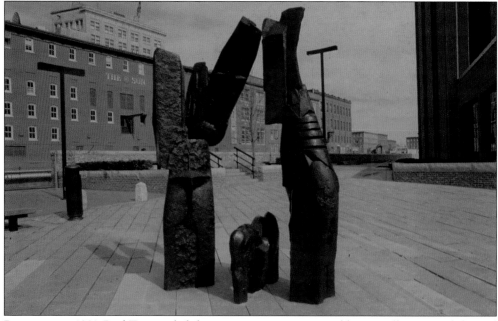

Beginning in 1981, Paul Tsongas led the movement to create a public art collection with he and his wife, Niki, personally commissioning a sculpture by Dimitri Hadzi called *agápetimé*, which means "love and honor" in Greek. This bronze-and-granite sculpture sits at Lower Locks, at the junction of the Pawtucket and Eastern Canals. (Courtesy of Kevin Harkins.)

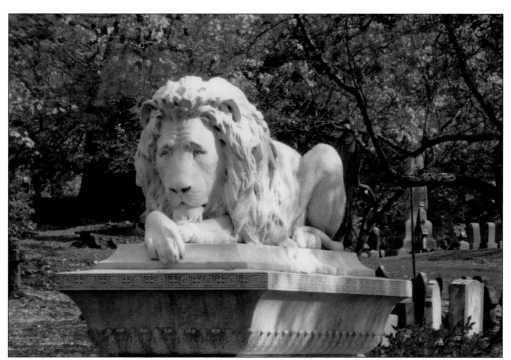

When James C. Ayer died in 1878, his family spent part of the fortune he had amassed in the patent-medicine business commissioning Irish-born sculptor Albert Bruce-Joy to create a monument for Ayer's grave in Lowell Cemetery. The resulting piece, made of Italian marble, depicts a life-sized lion with a sad contemplative face, gracefully at rest. (Author's collection.)

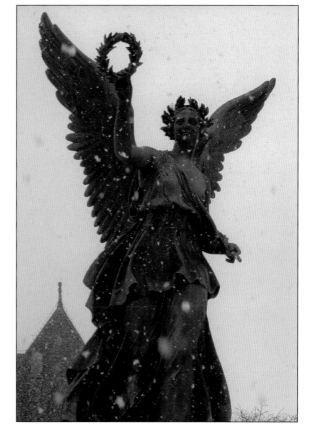

Standing on a grassy triangle in front of city hall, the Victory Monument, also known as *Winged Victory*, depicts a bronze angel extending a wreath in one hand and holding a sheaf of wheat in the other. Commissioned by James C. Ayer, who presented it to the city in honor of the Union victory in the Civil War, the monument was unveiled on Independence Day 1867. (Author's collection.)

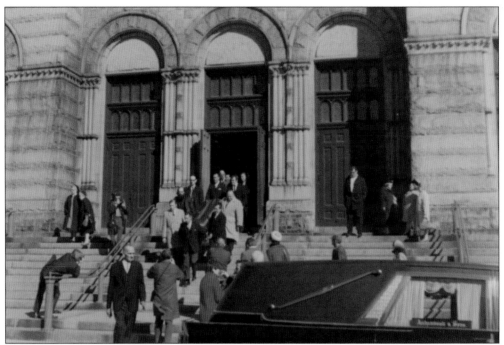

Lowell native Jack Kerouac, who chronicled the Beat Generation in numerous books, including several based in Lowell, died in Florida on October 21, 1969, at age 47. His funeral, held three days later in Lowell at St. Jean Baptiste Roman Catholic Church, was attended by literary figures such as Allen Ginsberg and Gregory Corso as was his burial in Lowell's Edson Cemetery. Kerouac repeatedly drew upon Lowell and its ethnic, religious, and working-class culture for much of his work with his writing, foreshadowing major American cultural shifts in the 1960s and 1970s. (Both, courtesy of Dean Contover.)

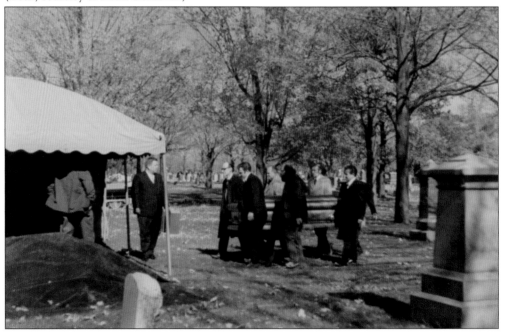

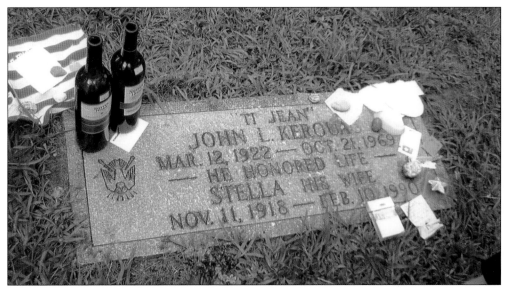

Jack Kerouac's grave marker in Edson Cemetery became a shrine to the writer, with admirers leaving medals, cigarettes, liquor, and other artifacts. For nearly two decades, it was the only tangible reference to Kerouac in Lowell. In the summer of 1988, however, Lowell dedicated a public memorial to Kerouac in a ceremony attended by 1,000 people, including two of Kerouac's three wives and poets Lawrence Ferlinghetti (left) and Allen Ginsberg (right). Designed by Houston sculptor Ben Woitena, the *Jack Kerouac Commemorative* contains excerpts from Kerouac's writings inscribed on polished granite blocks set to form a cross and a series of circles that acknowledge Kerouac's Roman Catholic and Buddhist beliefs. (Above, courtesy of the National Park Service; below, courtesy of Dean Contover.)

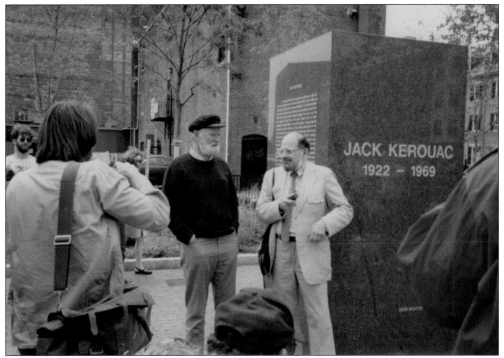

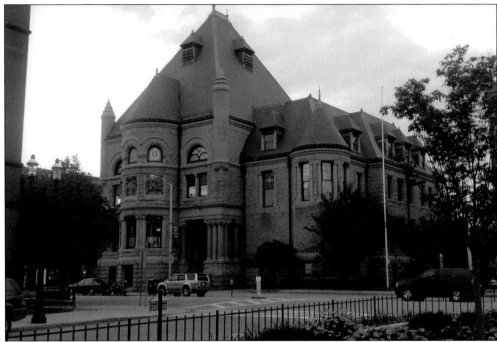

In the 1890s, the need for a suitable memorial for Civil War veterans and a new city library converged with the construction of Memorial Hall. Repairs after a major fire in 1915 included the addition of three enormous paintings by French artist Paul Phillippoteaux that depicted the military career of Ulysses S. Grant. With the passing of the Civil War generation, the veterans' space on the second floor became school department offices while the library continued to occupy the first and basement floors. In 1981, the city council voted to rename the building the Pollard Memorial Library in honor of longtime councilor and mayor Samuel Pollard. A $10 million renovation in 2002 restored the library to its original grandeur. (Above, author's collection; below, courtesy of Marianne Gries.)

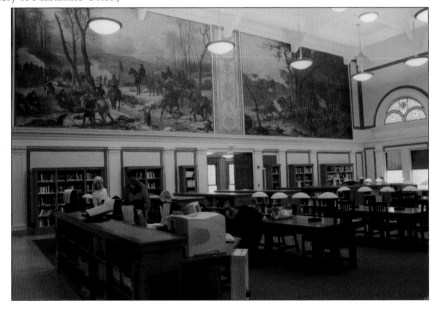

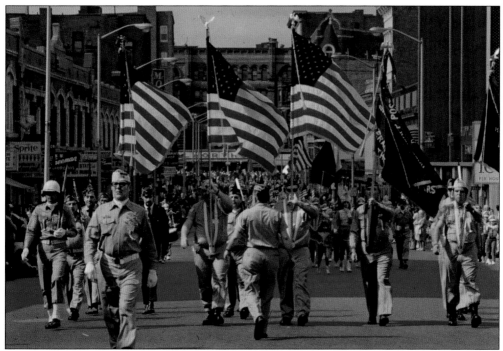

Parades were major civic celebrations in Lowell through the decades and centuries. Above, a color guard of military veterans marches up a crowded Central Street while a US Army tank lumbers past city hall, its steel tracks leaving a permanent mark in the pavement as it passes by, below. Whatever the occasion, parades typically included military units from nearby Fort Devens, marching bands, veterans' organizations, and community and youth groups with elected officials and dignitaries leading the way before mounting a reviewing stand near the end of the parade route. (Above, courtesy of RH; below, courtesy of Mary Howe.)

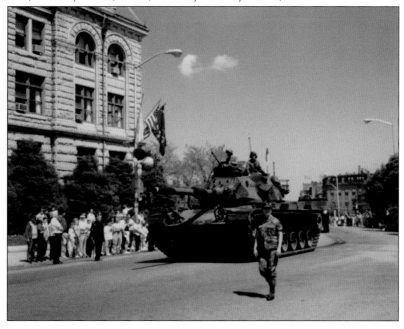

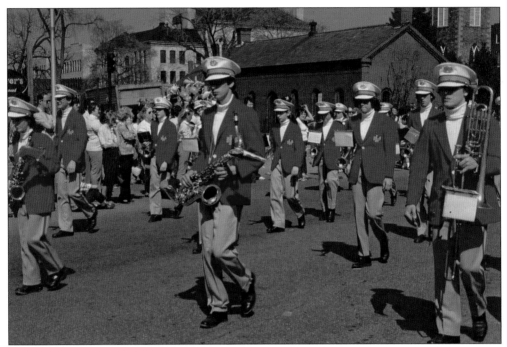

Established on January 1, 1923, under the direction of John J. Giblin, the Lowell High School band has been an integral part of the school and the city ever since, playing at football games and special events, marching in parades, and performing in concerts. As one of the only high school bands in the state to routinely play the Greek National Anthem due to its participation in the city's annual Greek Independence Day observation, the Lowell High band was summoned to Logan Airport in May 2005 by Gov. Mitt Romney to welcome Greek prime minister Kostas Karamanlis to Massachusetts by playing his country's national anthem as he disembarked from his plane onto the airport runway. (Above, courtesy of RH; below, courtesy of MA.)

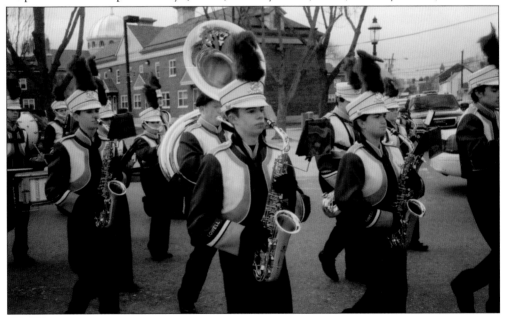

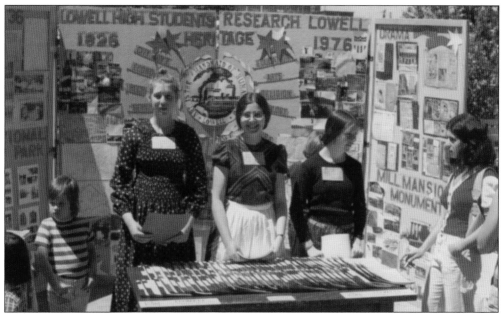

Not only was 1976 the bicentennial of the United States, it was also the sesquicentennial of Lowell's receipt of its town charter. Here, Lowell High School students staff a booth that illustrates the city's 150-year history during a commemorative event at Lucy Larcom Park that was part of a yearlong celebration with lectures, performances, a formal ball, and a 140-pound birthday cake. (Courtesy of Marie Sweeney.)

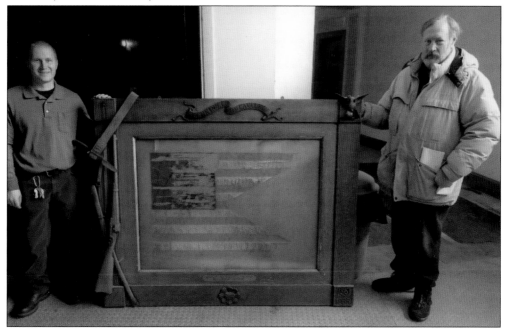

When Steve Purtell (left) discovered a Civil War battle flag hidden in the basement of the Lowell Memorial Auditorium in January 2014, he and his coworker Gus Kanakis (right) contacted the Greater Lowell Veterans Council, which has since restored the flag and its frame, a memorial to Lt. Solon Perkins, who was killed in action on June 3, 1863, at Clinton, Louisiana. (Author's collection.)

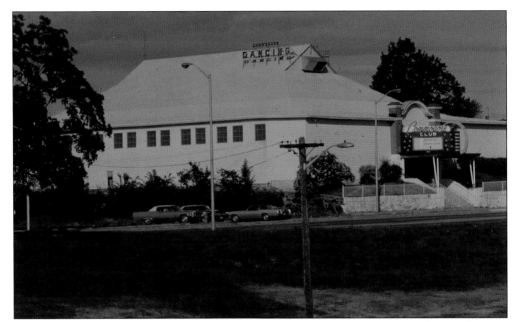

In 1924, Carl Braun bought an old roller skating rink on Thorndike Street and turned it into the Commodore Ballroom, which hosted premier performers, including Louis Armstrong, Frank Sinatra, Glenn Miller, Cream, and the Doors. The Braun family sold the Commodore in 1972. A decade later it was torn down, eventually becoming the site of a parking garage at the Gallagher train station. (Courtesy of RH.)

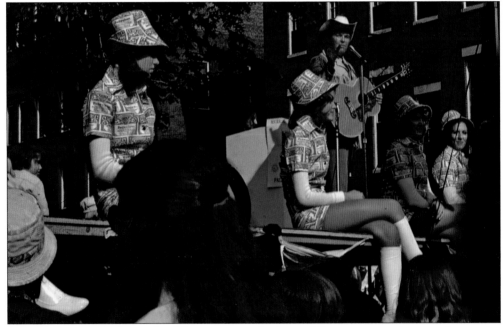

In 1956, Rex Trailer began his 20-year run as the host of *Boomtown*, an immensely popular children's show on Boston television. Rex made numerous appearances in Lowell, including this one as part of the 1974 Regatta Festival, which also involved Lowell-native Ed McMahon and the Budweiser girls. (Courtesy of Joseph Amaral.)

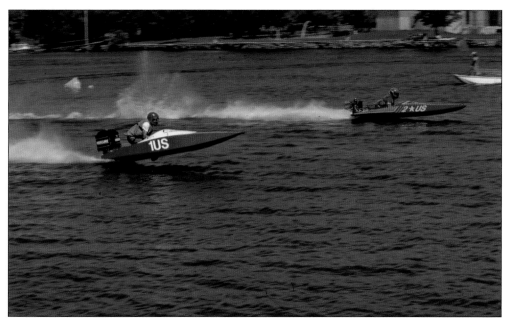

On summertime weekends in the 1960s, Lowell residents, even those far from the river, were serenaded by the high-pitched whine of speedboats racing on the Merrimack at speeds in excess of 70 miles per. The Merrimack also claimed the attention of Xenophon "Zenny" Speronis, whose Speare House Restaurant was located along the river. Frustrated that the city was forsaking promotional opportunities presented by the river, Speronis and a group of volunteers created the Regatta Festival Committee, which organized three major festivals in Lowell in 1974, beginning a tradition of well-attended multicultural civic events that helped convince Congress to create Lowell National Historical Park. (Both, courtesy of RH.)

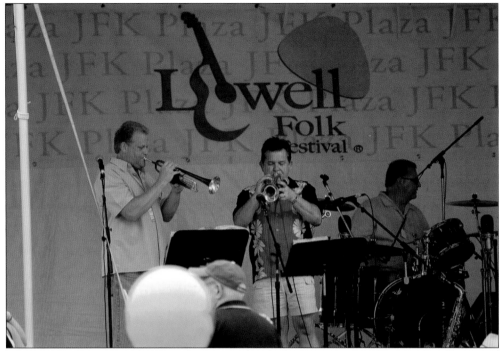

Originating in 1987 and held on the last weekend of July ever since, the Lowell Folk Festival has become the longest-running free folk festival in the United States, with five stages around downtown Lowell hosting performances of traditional music, flanked by ethnic food booths and craft demonstrations. One of the main attractions of the festival is the serendipitous discovery of each year's favorite performer, which in the past have included a teenaged Alison Krauss and a pre-Riverdance Michael Flatley. Performers at the 2010 Lowell Folk Festival included Lenny Gomulka and the Chicago Push polka band and break dancers from Lowell's United Teen Equality Center. (Both, author's collection.)

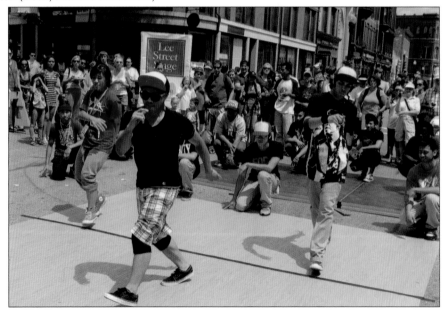

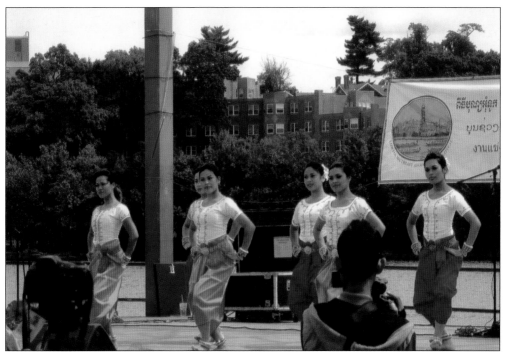

Held each August since 1997 along the banks of the Merrimack River, Lowell's Southeast Asian Water Festival celebrates the cultures and traditions of Khmer, Thai, Laotian, Vietnamese, and other Southeast Asian communities. The hundreds of vendors and performers who participate in the festival routinely draw more than 50,000 visitors from across the United States and Canada. Performances by the Angkor Dance Troupe, founded in Lowell in 1986 to preserve Cambodian cultural traditions, are always a festival highlight as are boat races that celebrate the importance of rivers in Southeast Asian life. (Above, author's collection; below, courtesy of Jennifer Myers.)

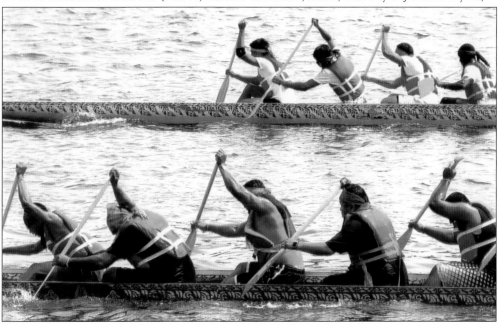

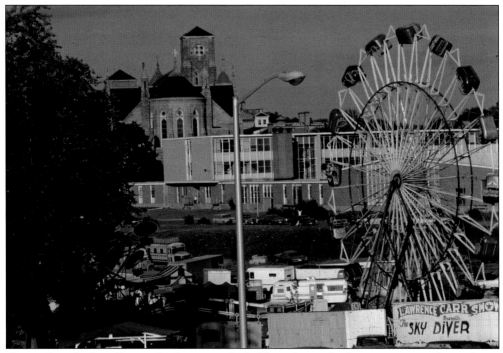

Carnivals with their Ferris wheels, carousels, kiddie rides, and other amusements have always drawn crowds in Lowell. Ranging from large carnivals that set up on the South Common or Regatta Field to smaller operations that help raise money for churches or community organizations, carnivals bring a sense of the exotic to the city. (Courtesy of RH.)

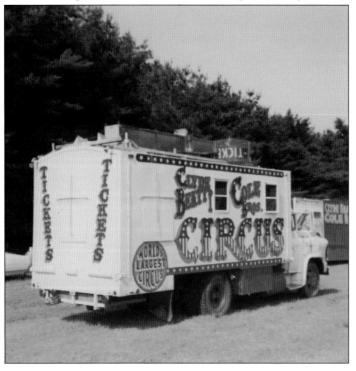

Prior to World War II, the circus was the dominant form of live entertainment in America, but suburbanization and television contributed to hard times for the circus business. The Clyde Beatty Cole Brothers Circus continued operating in big top canvas tents with traditional circus acts well into the 1970s, with frequent visits to Lowell. (Courtesy of Bill Walsh.)

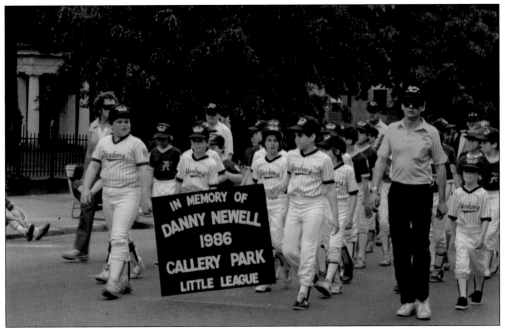

By the 1960s, separate Little League organizations existed in every neighborhood of the city, bringing umpires, uniforms, and equipment to city kids who would otherwise be playing with bats and balls held together with nails and black electrical tape. Here, the Callery Park Little League Yankees honor their much-beloved and recently departed coach, Dan Newell. (Courtesy of RH.)

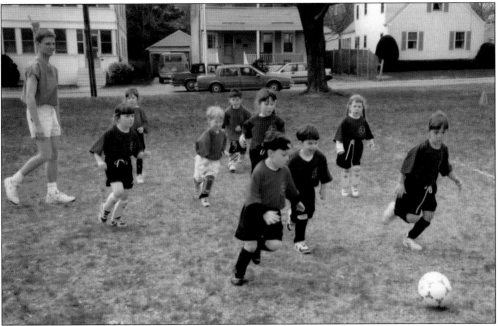

Baseball was always the most popular youth sport in Lowell, but it drew competition in the 1990s with the emergence of the Lowell Youth Soccer Association, which introduced thousands of boys and girls, age three to 18, to the world's most popular sport at fields and vacant lots across the city. (Author's collection.)

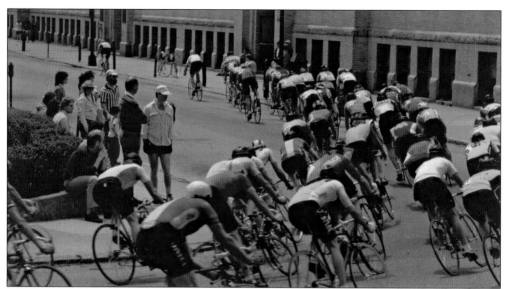

Sponsored by the *Lowell Sun*, the City of Lowell, and the Coca-Cola Bottling Company of Lowell, the Tour de Lowell brought hundreds of bicycle racers to the city in the 1980s and 1990s for a race of nearly 30 miles through Lowell, Tyngsborough, and Dunstable, another example of the diverse festivals and events that attract thousands of visitors while contributing to the city's vitality. (Courtesy of RH.)

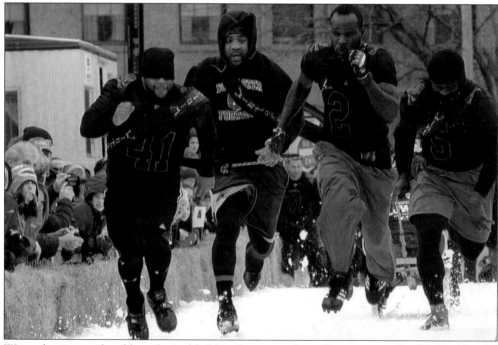

Winterfest is a weekend-long festival held in downtown Lowell every winter highlighted by the human dogsled race in which teams of six humans (four sled pullers, one sled pusher, and one sled rider) pull dog sleds in a weekend-long racing competition. A perennial contender for first place is the team fielded by the Lowell Nor-Easters, the city's semiprofessional football team. (Courtesy of Jennifer Myers.)

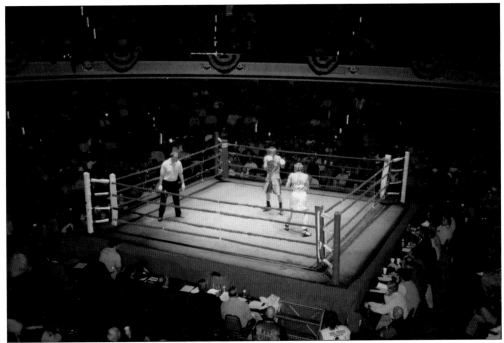

The New England Golden Gloves competition has been held every year since 1945 at the Lowell Memorial Auditorium. Past competitors have included Rocky Marciano, Sugar Ray Leonard, Marvin Hagler, and Micky Ward. Despite the declining popularity of boxing, the Golden Gloves remains a top draw in Lowell. (Courtesy of MA.)

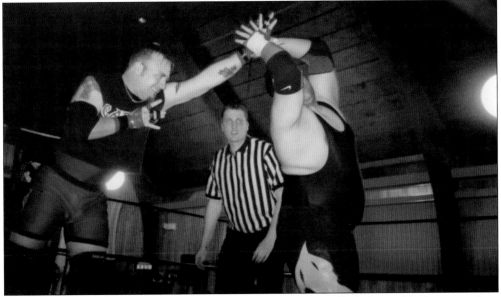

Professional wrestling has had many enthusiastic fans in Lowell, with notable figures such as Chief Jay Strongbow, Gorilla Monsoon, Killer Kowalski, and Andre the Giant frequent visitors to the city. The biggest matches were held at the Lowell Memorial Auditorium, but smaller venues such as the Polish American Veterans Club continue to be popular sites for professional wrestling. (Courtesy of MA.)

The Lowell Lock Monsters arrived in Lowell in 1998 as the American Hockey League affiliate of the New York Islanders. Their mascot, Louie the Lock Monster, proved more popular than the team despite its local ownership. The Lock Monsters were replaced in 2006 by the Lowell Devils, an affiliate of the New Jersey Devils, but the Devils and professional hockey departed in 2010. (Author's collection.)

The UMass Lowell River Hawks men's ice hockey team is always near the top of the highly competitive Hockey East Association at the NCAA Division I level. Here, UMass Lowell mascot Rowdy the River Hawk joins fans Kevin McManimon and Fahmina Zaman at the 2014 Frozen Four tournament at Worcester's DCU Center. (Courtesy of Fahmina Zaman.)

Founded in 1996, the Lowell Spinners are the Class-A affiliate of the Boston Red Sox and play in the short season New York-Penn League. Many current and former Red Sox players such as Jacoby Ellsbury, Hanley Ramirez, and Mookie Betts made their professional baseball debuts with the Spinners. Besides the opportunity to see the Red Sox stars of tomorrow, fans flock to LeLacheur Park for its summertime beauty along the bank of the Merrimack River and the always innovative between-innings entertainment such as the mascot race featuring Canaligator, Allie-Gator, and friends. (Both, author's collection.)

Like baseball fans across New England, residents of Lowell endured decades of heartbreak at the hands of the Boston Red Sox. That all changed in 2004 when the team won its first World Series since 1918. Here, fans at the Bench cheer the decisive moment on October 27, 2004, when the Sox swept the St. Louis Cardinals. (Courtesy of MA.)

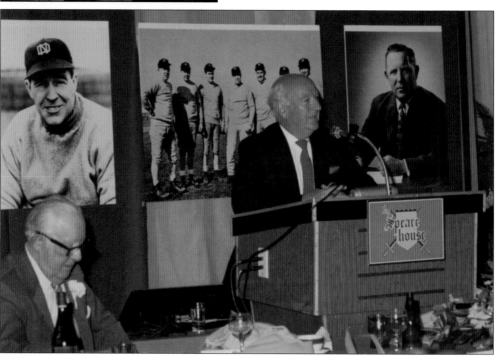

In 1960, Lowell native Billy Sullivan purchased one of the charter franchises of the American Football League and ran the team, called the Boston (later New England) Patriots until he sold it in 1988. Sullivan is shown here speaking at a testimonial at the Speare House Restaurant honoring fellow Lowell High graduate and longtime Notre Dame assistant football coach Joe McArdle. (Courtesy of Jack and Donna Connell.)

Four

LIFE IN LOWELL

Lowell is a low-lying city with only a handful of tall buildings—Cross Point, Fox Hall, Merrimack Plaza, and the Sun Building—but the historical city plan with the mill layout and canal system fed by the Merrimack River is best understood when viewed from above as in this view from East Merrimack Street looking west across downtown Lowell. (Courtesy of Paul Richardson.)

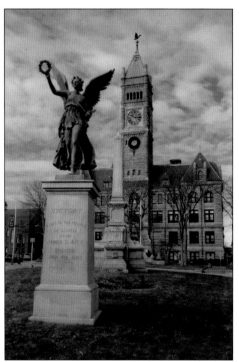

The population of Lowell increased dramatically in the decades following the Civil War and so did the need for a larger, more active municipal government. In the 1890s, a city hall commission was appointed by local elected officials to oversee the construction of a new and bigger city hall and an adjacent Public Library/Veterans Memorial building on Merrimack Street. Both buildings were dedicated in 1893. (Author's collection.).

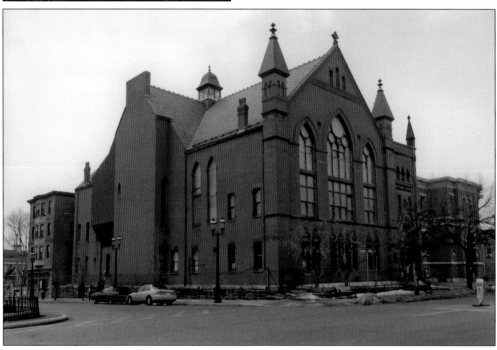

Originally the First Congregational Church, the large redbrick building across from city hall became the city's senior citizens' center in 1968 when it was renamed the Smith Baker Center in honor of the church's longtime pastor. Its majestic second-floor public space hosted talks by John Updike, Maya Angelou, and Allen Ginsberg but fell into disrepair when the senior center moved. The building awaits redevelopment. (Author's collection.)

As the rock-and-roll era reached Lowell, Record Lane on Central Street became a regular stop for teenagers seeking the latest 45s and record albums. Its extensive inventory of costumes made Halloween the busiest time of the year. Next door was Ray Robinson's, a popular breakfast and lunch spot for downtown workers, run for decades by Ray Robinson and his son Dave. (Courtesy of MA.)

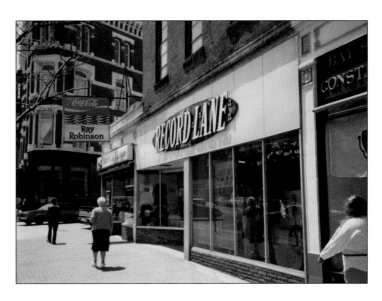

Constructed in 1917, the Strand Theatre featured a lavish lobby and seated 1,700, making it one of the city's largest theaters. The Strand stayed in business into the 1970s. Numerous attempts to save it failed. In the early 1980s, it was demolished to uncover the Pawtucket Canal and make way for the newly constructed Hilton Hotel and Wang Training Center. (Courtesy of RH.)

When brothers Stanley and Sidney Goldstein and their friend Ralph Hoagland opened a store selling health and beauty products at affordable prices at 118 Merrimack Street in 1963, they called it CVS, short for Consumer Value Store, the first in a chain of now 7,000 stores with $100 billion in annual revenue. (Courtesy of PML.)

The Mansur Building at 101 Central Street is one of a handful of buildings in downtown Lowell that was constructed in the 1830s. It shares with modern buildings the tendency for large icicles to accumulate in winter. This photograph from the 1980s shows members of the Lowell Fire Department removing icicles to safeguard pedestrians. (Courtesy of Vassilios Giavis.)

When Frederick Woolworth opened his Woolworth's Great Five Cent Store in Lancaster, Pennsylvania, in 1879, he launched not only a retail establishment, but a cultural phenomenon known as the five-and-ten. Downtown Lowell had Woolworth's, Kresge's, Newbury's, and Green's. All offered inexpensive personal and household items, and most had lunch counters with tasty and affordable food, soda, ice cream, and desserts. (Courtesy of RH.)

A Civil War veteran, Dudley L. Page opened his candy store in 1866. By 1913, he added ice cream to the menu and moved to Merrimack Square (later renamed for Lt. Paul Kearney who was killed in action during World War I), where he erected a large sidewalk clock that remains a Lowell icon, known to all as Page's Clock. (Courtesy of RH.)

Family friends Nathan and Sally Birke fled Poland ahead of the Nazi terror in 1939 and, out of a sense of propriety, soon married. Heading east, they found work and survived in Siberia for the duration of World War II. With both of their families wiped out by the Nazis, Nathan and Sally began the journey that brought them to Lowell. They opened their first clothing store in 1948 on Back Central Street, moved to Gorham Street, and then relocated to Market Street in 1960, where the store remained for 44 years. Birke's became a Lowell institution famous for top-quality merchandise at amazing prices and a brusquely enforced "no browsing" policy. Nathan died in 1992. Sally passed away in 2012 at age 92. (Above, courtesy of RH; below, courtesy of Szifra Birke.)

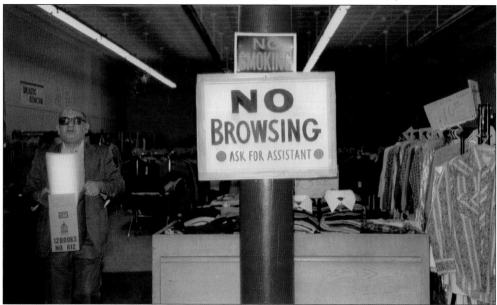

WORK SAVER for my WORK CENTER

Lowell's telephone exchange, established in 1878 by Charles Glidden, was the fourth in the nation after New Haven, Connecticut; San Francisco, California; and Albany, New York. The following year, physician and telephone company investor Moses Greeley Parker, concerned that a measles epidemic would quarantine the city's four telephone operators, suggested to his friend Alexander Graham Bell that numbering the phone lines would make it easier to train new operators. Bell concurred, and the telephone number was born. For more than 100 years, New England Telephone & Telegraph brought technology and jobs to Lowell. Above, Mary Smith tries out a state-of-the-art secretarial workstation in 1957. Below, from left to right, Dot Munroe, Dot Lynch, Janet Vassar, and Geri Powers enjoy one of the many celebrations held for promoted, retiring, or marrying phone company employees. (Both, courtesy of Mary Howe.)

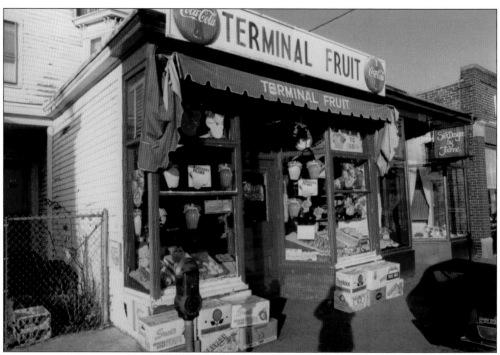

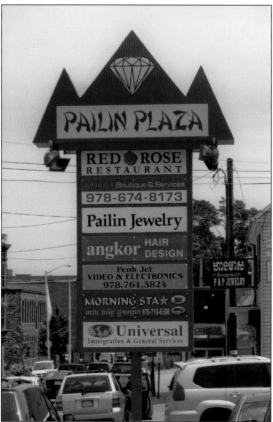

Named for Lt. Lorne Cupples, who was killed in action in France in 1918, Cupples Square has been a vibrant neighborhood shopping district in the Highlands neighborhood for decades. Stores like Terminal Fruit at 313 Westford Street, which served the Irish and French Canadians who lived in the vicinity, gradually gave way in the 1990s to Cambodian-owned businesses as the demographics of the neighborhood changed. (Courtesy of Steve O'Connor.)

A majority of the Southeast Asians who came to Lowell settled in the Lower Highlands neighborhood, where Cambodian-owned businesses thrive. Pailin Plaza, built in the early 1990s, features restaurants, grocery stores, jewelers, clothing stores, and other retail establishments. Pailin is a Cambodian province where diamonds and gold were mined, so the name evokes prosperity while the pagoda-like design of the plaza recalls Cambodian building styles. (Author's collection.)

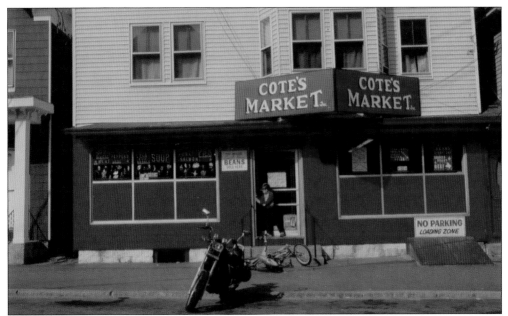

Cote's Market, a fourth-generation family business that has occupied the same spot on Salem Street for almost 100 years, serves 300 pounds of their famous baked beans each week along with other French Canadian specialties such as Chinese pie and pork scrap. Every Saturday morning, lines of people, most addressed by name, answer the query "With or without?" by stating their preference for beans with chunks of salt pork or without. Here, Roger Levasseur, whose grandfather Joseph Elphege Cote opened Cote's Market in 1917, and Stephanie Quinones, offer a pint of beans and a pork pie, two of Cote's most popular products. (Above, courtesy of PML; below, courtesy of MA.)

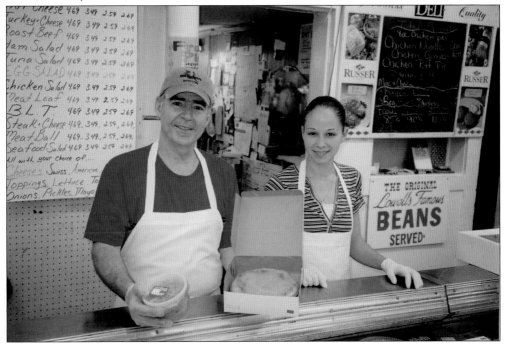

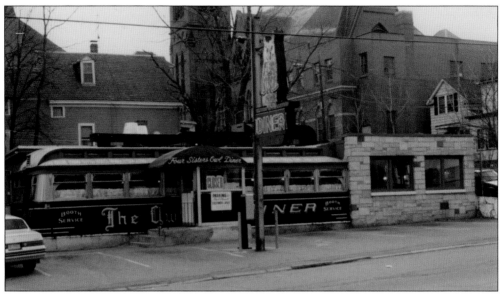

First located on Main Street in Waltham as the Monarch Diner, 1940s-era Worcester Lunch Cart No. 759 moved to Lowell in 1951 and became known as the Owl Diner. In 1982, it was purchased by the Shanahan family and renamed the Four Sisters' Owl Diner. The Owl provides Lowell residents with an authentic diner experience for breakfast and lunch while serving as the favorite meeting place of politicians and city leaders. Taking advantage of the diner's popularity, the Shanahans give back to the city through Owl Diner Charities, which provides assistance to community members in need. From left to right are Martha Kataftos, Marybeth Shanahan, and Rosie Gauthier, all members of the Shanahan family and all of whom have since opened diners of their own in the region. (Both, courtesy of Vassilios Giavis.)

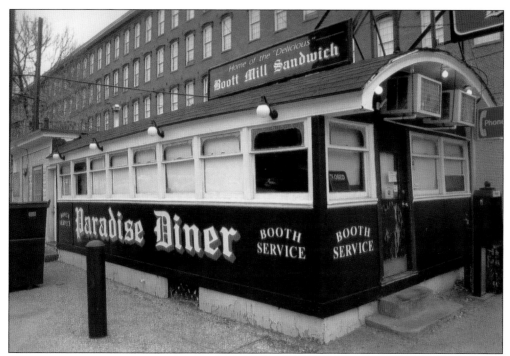

Arthur's Paradise Diner is a 1937 Worcester Lunch Car long located alongside the Boott Cotton Mills, which inspired its signature dish, the Boott Mill, which features eggs, cheese, home fries, and a choice of bacon, ham, or sausage, all on a grilled bulkie roll. Originally intended for mill workers, the Boott Mill is now the favorite breakfast sandwich of students at nearby Lowell High School. (Author's collection.)

The Cameo Diner on Lakeview Avenue is a small family-owned and -operated diner where breakfast often serves as an intergenerational bonding experience. Frequent visits to the Cameo inspired Lowell-native Matt Miller to capture the rhythm and cadence of the English language as spoken in Lowell in a diner poem in the book *Cameo Diner*, published by Loom Press in 2005. (Courtesy of Paul Richardson.)

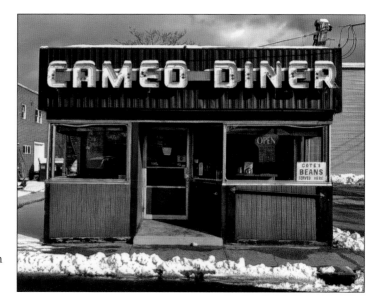

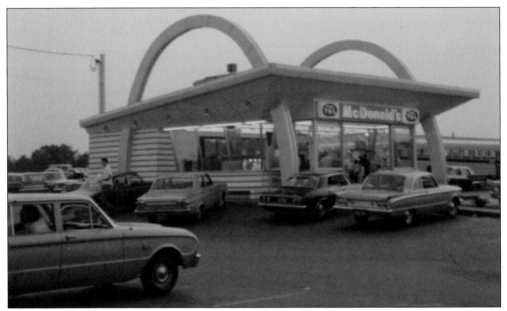

The first McDonald's in Lowell was built in 1960 on Rogers Street, not far from Route 495, using the original company design of signature golden arches threaded through the sloped roof of the structure. Customers would place their order within the glassed-in vestibule, but there was no seating inside, which was consistent with the car culture of the time. (Courtesy of Bill Walsh.)

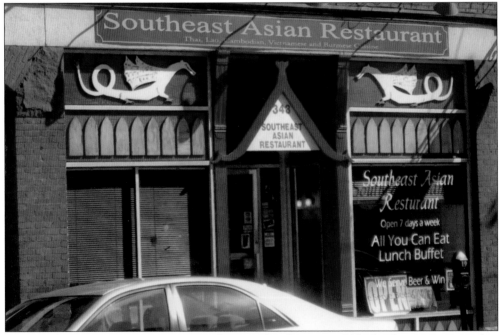

The Southeast Asian Restaurant opened on Market Street in 1985, the first restaurant of its type in the city. Founder Joe Antonaccio had discovered Southeast Asian cuisine while serving with the US Air Force in Thailand in the 1960s, and he and his Laotian-born wife, Chanthip, brought authentic recipes from the region to their restaurant and introduced Lowell residents to authentic Southeast Asian cooking. (Author's collection.)

Into the 1980s, a majority of Lowell's residents were practicing Roman Catholics who abstained from meat on Fridays, making fish stores like the one owned by William Hoare busy places. Tom Sexton, a 1940 graduate of Lowell High School who became Alaska's poet laureate, wrote a poem called "Hoare's Fish Market," referring to Hoare as "our Neptune in tall boots." (Courtesy of PML.)

Charles Santos was part of a large Portuguese family from the Azores. After working in Lowell's mills as a child, he founded Charles Santos & Sons, Inc., a wholesale meat store on King Street, which he operated for more than 30 years. His son Charles R. Santos served as Lowell's postmaster from 1967 to 1979 as part of a distinguished career with the US Postal Service. (Courtesy of Patricia Nickles.)

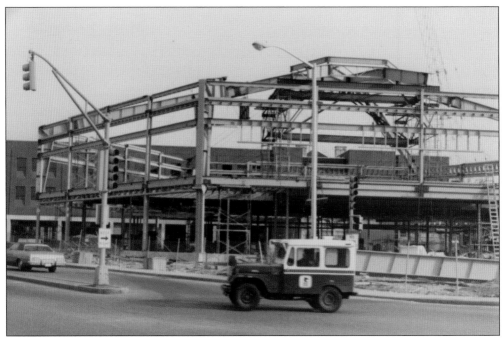

Established in 1831, Lowell High School was the first integrated and the first coeducational public high school in the United States. In the late 1970s, the City of Lowell constructed a major addition to the school on the site of the former Merrimack Manufacturing Company boardinghouse on Dutton Street. The new addition, called "the 1980 building," consists of administrative offices, classrooms, a cafeteria, and a large field house. A $40-million expansion in the late 1990s added more classrooms, a library/media center, and a state-of-the-art television studio. (Above, courtesy of Dean Contover; below, courtesy of Sevy Doung.)

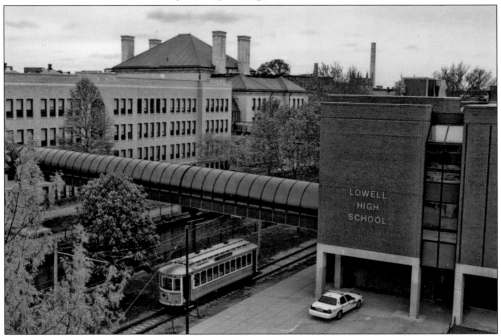

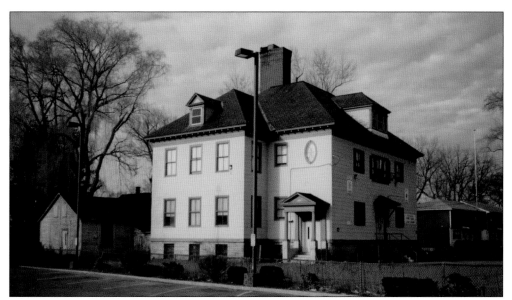

Constructed in 1895, the Middlesex Village School was representative of the small wood-frame schools the city school department would build as new neighborhoods became populated with families. A lack of basic facilities led the city to close or repurpose these schools in the 1980s. The Middlesex Village School was eventually demolished to make way for retail development on outer Middlesex Street. (Courtesy of MA.)

Named for former Lowell mayor and Massachusetts governor Frederic Greenhalge, who championed public education while in office, the Greenhalge was one of a dozen new schools built in the 1990s with 90 percent state funding after Lowell adopted a qualified desegregation plan as part of the negotiated settlement of a federal lawsuit brought against the city. (Author's collection.)

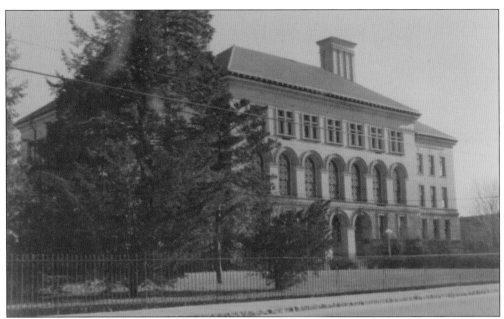

Coburn Hall (above) became the first home of the Lowell Normal School, a teacher training academy established in 1894 and renamed State Teachers College at Lowell in 1932. A second state college in Lowell, Lowell Textile School, was founded in 1895 to grant specialized degrees in textile manufacturing. Gradually, the textile school's focus shifted to all areas of engineering, so in 1953, it was renamed Lowell Technological Institute. In 1975, the two schools merged to form the University of Lowell, which became University of Massachusetts Lowell in 1995. UMass Lowell chancellor Marty Meehan credits former state representative Paul Sheehy as the chief architect of the merger, saying, "We would not have a world class public research university in Lowell without Paul Sheehy." (Above, courtesy of Dean Contover; below, courtesy of RH.)

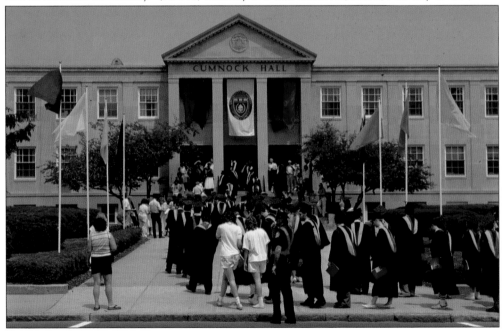

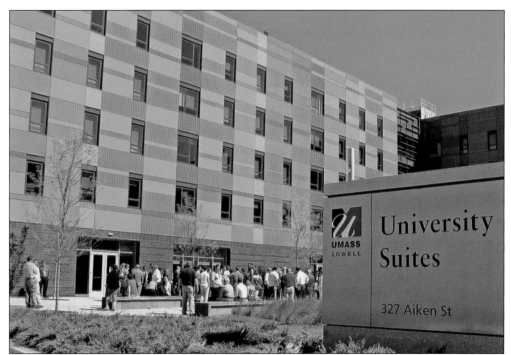

Since Marty Meehan became chancellor of the University of Massachusetts Lowell in 2007, the endowment doubled, enrollment increased 48 percent, research funding surged, and the campus added 10 new buildings, including University Suites, a boldly colored, $54 million residence hall across the street from LeLacheur Park, and the Saab Emerging Technologies and Innovation Center, an $80 million complex supporting nanotechnology, life sciences, and chemical engineering. Meehan, who in 2015 was chosen to be the president of the entire University of Massachusetts system, is shown in the photograph below at the podium with, from left to right, former state senator Steven Panagiotakos, Gov. Deval Patrick, UMass president Robert Caret, Congresswoman Niki Tsongas, and UMass Lowell vice provost Julie Chen. (Above, courtesy of Jennifer Myers; below, courtesy of UMass Lowell.)

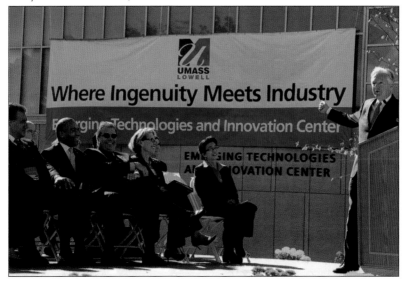

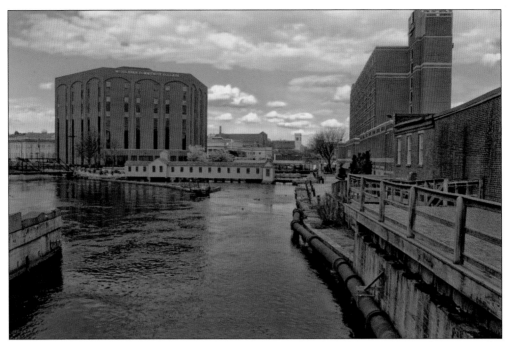

Middlesex Community College first came to Lowell in 1987 when it occupied space at the Wannalancit Mills. In 1990, the college purchased the former Wang Training Center across the Pawtucket Canal from the Lowell Hilton for classroom and office space. In 2015, the building was renamed the Dr. Carole A. Cowan Center for the college's recently retired president. (Courtesy of Ariana Ly.)

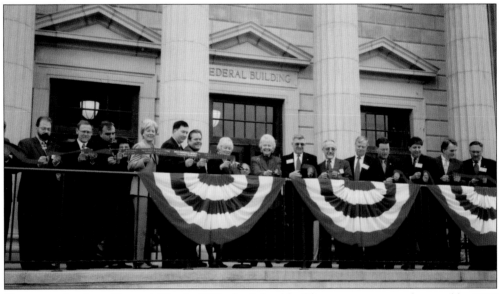

Constructed as Lowell's post office in 1936, the federal building was vacant and unused by 1998 when it was transferred to Middlesex Community College. Following extensive interior renovations, the building was dedicated in a 2005 ceremony that featured Margaret Marshall, the chief justice of the Massachusetts Supreme Judicial Court, and was renamed the F. Bradford Morse Federal Building for Lowell's congressman during the 1960s. (Courtesy of MA.)

Ever since 1822, when the mill owners granted an acre of land to the first Irish laborers for housing, the Acre has been the landing place for generations of immigrants. The placement of the Holy Trinity Greek Orthodox Church (opened in 1908) directly across the street from St. Patrick's Roman Catholic Church (opened in 1831, rebuilt in 1853) symbolizes the Acre's diversity. (Author's collection.)

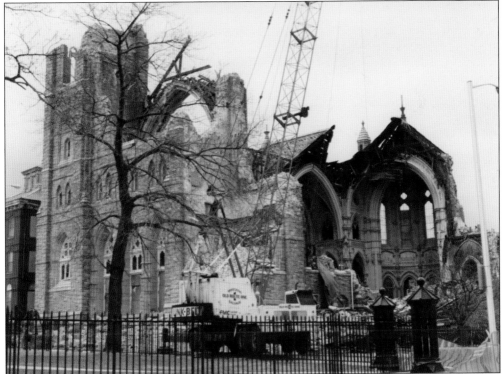

Built in 1892 according to a design by Patrick Keeley, the leading architect of Roman Catholic churches in America, St. Peter's Church housed an active, thriving parish for decades until demographic and physical changes in its Gorham Street neighborhood caused the church to close in 1986. After a decade of deferred maintenance, granite blocks began falling from its facade, and the church was demolished. (Courtesy of Vassilios Giavis.)

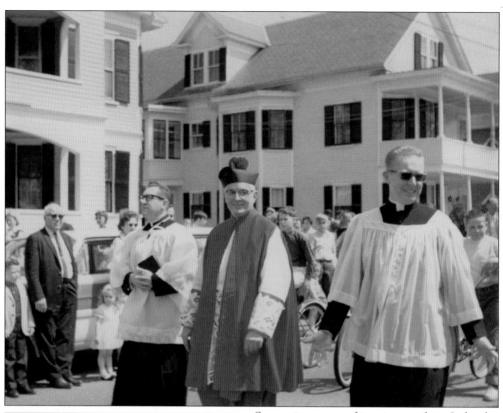

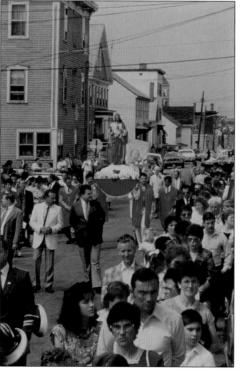

Successive waves of immigrants from Ireland, Quebec, Poland, and Portugal brought their Roman Catholic faith with them to Lowell. By the first decades of the 20th century, independent ethnic parishes had overlaid the geographic ones established by the Archdiocese of Boston. All dedicated the month of May to the Blessed Virgin Mary with well-attended public observances ranging from the St. Margaret's May Procession on Stevens Street in the Highlands (above), led by Rev. Laurence Cedrone (left), Msgr. Raymond Hyder (center), and Rev. Paul McEntee (right) to the St. Anthony's Parish observance of the Feast of Our Lady of Fatima on Chapel Street in the Back Central neighborhood (left). (Above, courtesy of Mary Howe; left, courtesy of Rosemary Noon.)

The Glory Buddhist Temple on Cambridge Street was established in 1989 in a former warehouse building as a monastery, community center, and place of worship in the Lower Highlands that serves the spiritual needs of the many Buddhists who live in the area and preserves the traditions, customs, and culture of Cambodia. (Author's collection.)

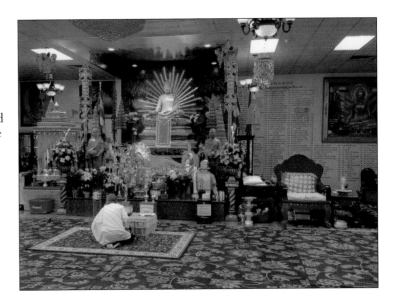

Members of the Keith Academy class of 1957 receive their diplomas in a graduation ceremony at St. Patrick's Church. A Catholic high school for boys that opened in 1926 in the former county jail, Keith Academy closed in 1970. Although a small school, the accomplishments of its graduates gave Keith outsized influence in Lowell for decades. (Courtesy of Mary Howe.)

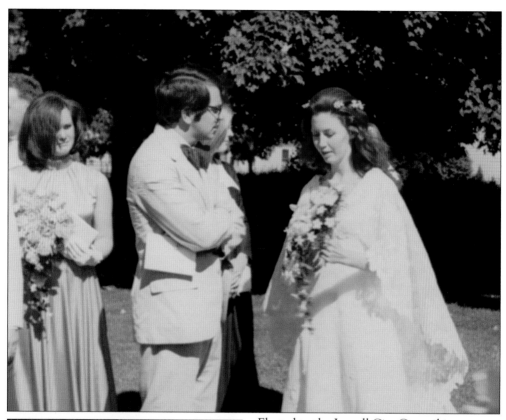

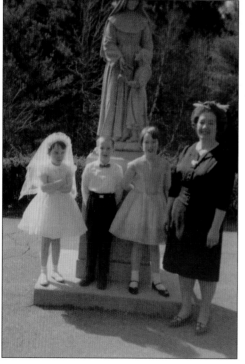

Elected to the Lowell City Council in 1971, Gail Dunfey married soon thereafter. Her decision to keep her last name after marriage ignited controversy at the time. Dunfey, pictured here on her wedding day with fellow city councilor Paul Tsongas, lost her 1973 reelection bid, an outcome many attributed to the name controversy. (Courtesy of Mary Howe.)

Each May, hundreds of white-clad second graders from Roman Catholic families in Lowell receive their first Holy Communion. Here, Peggy Shanahan, hungry after fasting for hours before receiving communion, has grown tired of family photographs, which stand in the way of blueberry pancakes at the Cupple's Square Diner. From left to right are Peggy, William, Catherine and Caroline Shanahan, pictured here in May 1963. (Courtesy of Peg Shanahan.)

Eastern European Jews arrived in Lowell in the 1890s, settling near Hale and Howard Streets in the Lower Highlands, a neighborhood of kosher markets, Hebrew schools, and synagogues. In the 20th century, much of Lowell's Jewish community relocated to the upper Highlands with Temple Beth El opening on Princeton Boulevard in 1926; Temple Emanuel being built on West Forrest Street in 1959; and Montefiore Synagogue, which dates to 1896 and is the oldest synagogue in Lowell, moving to Westford Street in 1979. The photograph at right shows James (left) and Adam (right) Mitchneck at Adam's 2001 bar mitzvah at the Montefiore Synagogue. The photograph below shows James Mitchneck bestowing his blessing on Ariela Mitchneck at her 2015 wedding. (Both, courtesy of Peg Shanahan.)

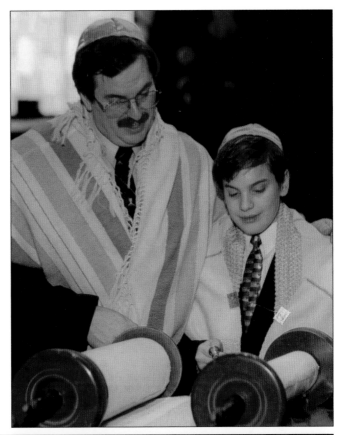

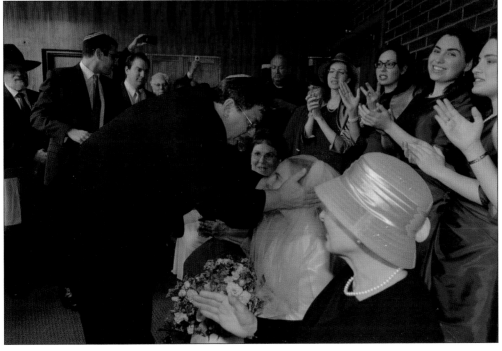

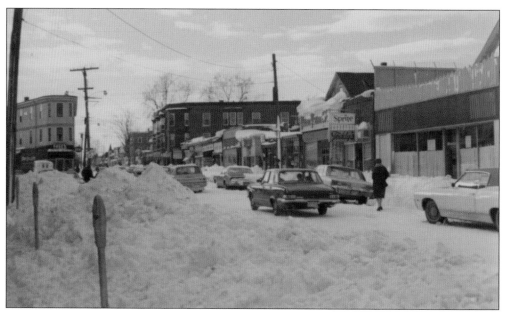

The average snowfall in Lowell is 51 inches, but winter precipitation varies greatly on a year-to-year basis. In February 1969, the area was hit with two major storms within a week, leaving more than two feet of snow, as seen in this post-storm photograph of Cupples Square, a neighborhood shopping district in the Highlands. (Courtesy of Dean Contover.)

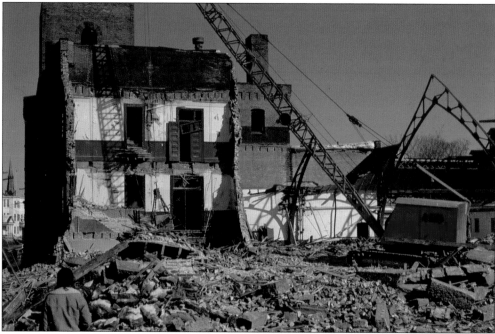

Built in 1890, the redbrick castle-like armory on Westford Street gave generations of National Guard troops a place to drill. With the end of the Vietnam War and selective service, the armory was no longer needed. In 1974, the Commonwealth of Massachusetts transferred the property to the city, which demolished the building and created a public green space called Armory Park. (Courtesy of RH.)

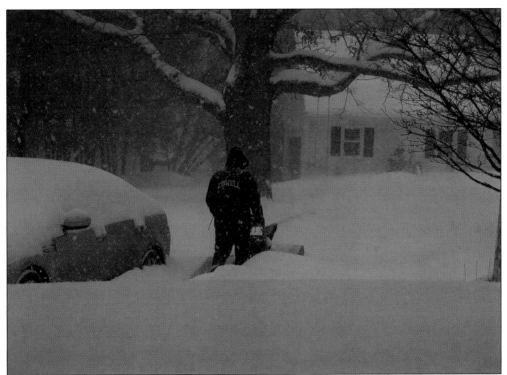

From late January through the end of February 2015, several major snowstorms struck Lowell in rapid succession, with temperatures rarely rising out of the single digits. Schools and businesses were closed for multiple days at a time, and hundreds of homeowners struggled to clear roofs of snow when ice dams caused water from the melting rooftop snow to pour through light fixtures and window casings. Help eventually arrived from the Massachusetts Army National Guard, which deployed troops to Lowell, where they were greeted by Mayor Rodney Elliott. In the end, Lowell received 120.6 inches of snow, the most of any city of more than 100,000 residents in the entire United States for the winter of 2014–2015. (Above, courtesy of Roxane Howe; below, courtesy of Rodney Elliott.)

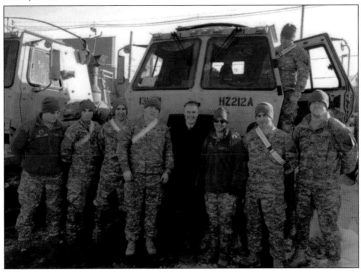

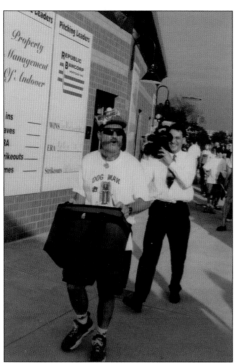

Lowell native Del Christman developed a cult-like following while vending hot dogs at Lowell Spinners games. "Dog Man," as he became universally known, dished out Golden Retrievers, Irish Setters, and Blood Hounds (hot dogs with mustard, green relish, or catsup). Here, Dog Man works the concourse of LeLacheur Park, trailed by local cable television news reporter Paul Malaragni. (Courtesy of MA.)

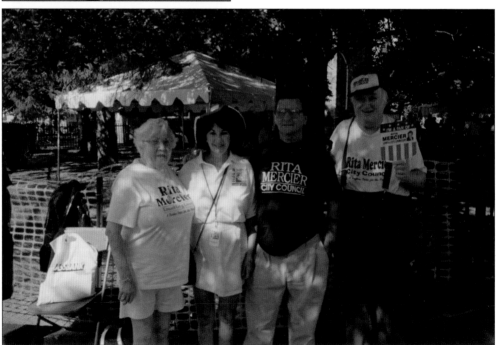

Elected to the Lowell City Council in 1995, Rita Mercier has been one of Lowell's most popular elected officials ever since, routinely topping the ticket in city council elections and serving as mayor in 2002 and 2003. Mercier is shown here in an early campaign with her husband, Ralph Mercier (second from right), and two of her strongest supporters, Erika Magill (left) and Paul Burton (right). (Courtesy of MA.)

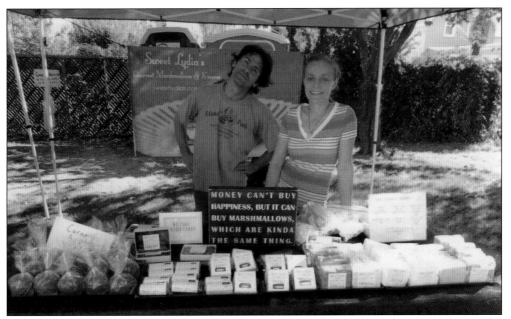

Lydia Blanchard's homemade marshmallows became so popular with friends and family that she opened Sweet Lydia's candy shop on Merrimack Street. Attendance at regional farmer's markets led to Sweet Lydia's being selected in 2015 as the retail candy store at the new Boston Public Market. Lydia is shown here at the 2013 Lowell Harvest Festival with Andy Jacobson, the founder and owner of Brew'd Awakening Coffeehaus. (Author's collection.)

Early Southeast Asian grocery stores helped create the cultural infrastructure that made Lowell home to so many people from that part of the world. The city soon had more than a dozen such stores selling an amazing assortment of imported vegetables, sauces, canned goods, beverages, and snacks, most of which cannot be found in typical American supermarkets. (Courtesy of MA.)

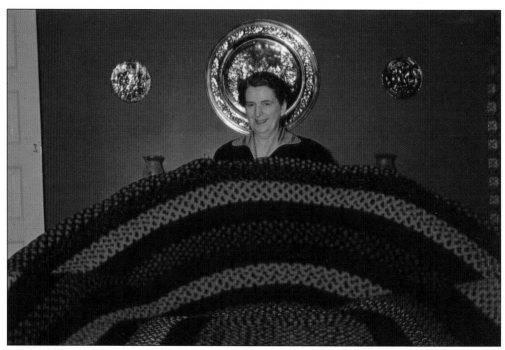

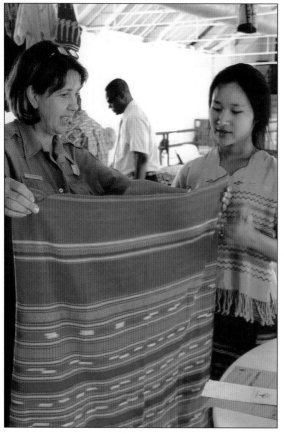

Trained as a milliner, Nora Gorman continued working with fabric after her marriage to Joseph Smith. Her specialty was handmade braided rugs, created by weaving together brightly colored strips of cloth into tight braids that were then stitched together with heavy twine. The resulting rugs were functional, durable, and beautiful works of art. (Courtesy of Mary Howe.)

In keeping with Lowell's historic role in the global textile industry, Lowell National Historical Park hosted in 2013 "Lowell Cloth Traditions" at its Boott Cotton Mills Museum. Featuring representatives of Lowell's American Textile History Museum and community members from Mali, Kenya, Burma, and Cambodia, the program explored traditional methods of weaving and dyeing from around the world. (Courtesy of Jennifer Myers.)

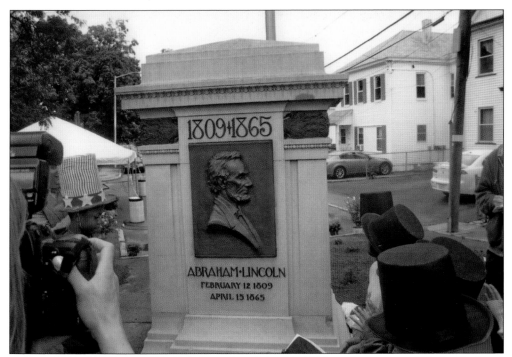

Sculpted by Bela Lyon Pratt and dedicated on May 31, 1909, at the corner of Chelmsford and Lincoln Streets, Lowell's eight-foot bas-relief bronze-and-granite monument to Abraham Lincoln cost $2,000, much of it raised from pennies donated by the schoolchildren of the city. A century later, battered by New England winters and the grit and fumes from passing vehicular traffic, the monument had assumed a dreary appearance. In 2010, the Lowell Heritage Partnership and the City of Lowell combined to restore Lowell's Lincoln Monument to its original luster. The rededication ceremony featured patriotic songs by students from the nearby Abraham Lincoln Elementary School. (Both, author's collection.)

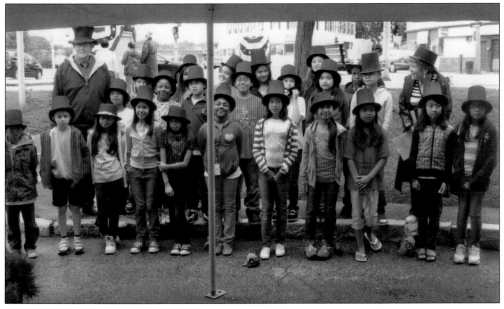

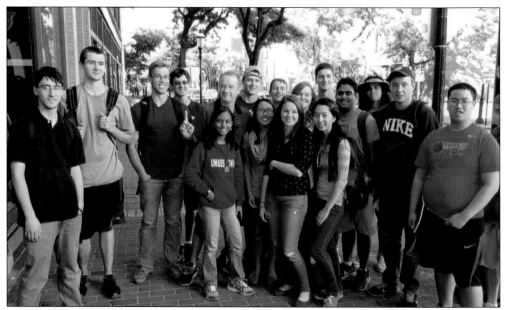

Patrick Mogan's vision of Lowell as a classroom without walls can be seen in action every day in downtown Lowell. In the photograph above, UMass Lowell students in a freshmen honors seminar that seeks to introduce the students to the history and culture of Lowell were thrilled to encounter Dick Ecklund, the half brother of boxer Micky Ward, during a walking tour of downtown Lowell. Ecklund, who was portrayed by Academy Award–winner Christian Bale in the movie *The Fighter*, graciously posed for a photograph with the students. In the photograph at left, a solitary student reads a selection from *On the Road* at the Jack Kerouac Commemorative. (Above, author's collection; left, courtesy of Tony Sampas.)